THE BEST OF
Nicole Routhier

THE BEST OF
Nicole Routhier

BY NICOLE ROUTHIER
photography by MARTIN JACOBS

Stewart, Tabori & Chang

NEW YORK

Published in 1996 and distributed in the U.S. by
Stewart, Tabori & Chang,
a division of U.S. Media Holdings, Inc.
575 Broadway, New York, NY 10012

Distributed in Canada by General Publishing Co. Ltd.
30 Lesmill Road, Don Mills, Ontario, Canada M3B 2T6
Distributed in Australia and New Zealand by Peribo Pty Ltd.
58 Beaumont Road, Mount Kuring-gai, NSW 2080, Australia
Distributed in all other territories by Grantham Book Services Ltd.
Isaac Newton Way, Alma Park Industrial Estate, Grantham,
Lincolnshire, NG31 9SD England

Library of Congress Catalog Card Number: 96-68946

ISBN: 1-55670-436-4

Edited by Mary Kalamaras
Designed by Lisa Vaughn

Printed in Singapore

10 9 8 7 6 5 4 3 2 1

FOREWORD

When I finished the manuscript of my first book, *The Foods of Vietnam*, and turned it over to my publisher, my strong feelings of pride were coupled with immense regret. I had thought the chance to write another Vietnamese cookbook would never present itself again. As it turned out, *The Foods of Vietnam* was very well received. Many people have told me that it has become their standard reference for Vietnamese cuisine, and it is still being discovered by many American cooks.

People have often asked me to name my favorite recipes. Actually, many of them are wonderful dishes that I wanted to include in *The Foods of Vietnam*, but there just wasn't enough room. I am so happy to have been given another opportunity to finally share my all-time favorite Vietnamese recipes with you.

In *The Best of Nicole Routhier*, I've selected dishes that I consider to be among Vietnam's greatest gastronomic delights. They also represent the kind of foods I enjoy cooking at home, as well as sharing with the public. Many are culled from *The Foods of Vietnam*, others are unpublished recipes that, until now, have been used exclusively in my cooking classes and demonstrations.

As Vietnam continues to evolve from an agrarian to an industrial economy, its age-old cuisine is prone to adaptation and westernization by modern cooks looking to streamline it. In light of these adaptations—and the fact that few cookbooks diligently or authentically document the sophistication of Vietnamese cooking—I believe most people who love Vietnamese cuisine will greatly appreciate the collection of classics found in this book. It is a continuation of my efforts to demystify and preserve a rich culinary tradition that is still not fully understood, but worth safe-guarding.

I consider the dishes in *The Best of Routhier* the "best" for several reasons: they are some of the finest and purest gems of a cuisine whose 2000-year-old traditions have changed very little over the centuries; these unique and lively childhood dishes, which I grew up treasuring, have consistently proven to be the most popular with non-natives; and most importantly, these dishes are easily re-created in your own kitchen, using the least complicated techniques to arrive at the most delicious results.

Though Vietnamese cuisine shares similarities with Thai and Chinese cuisines, it should not be confused with them. In northern Vietnam, there is a strong Chinese influence, as evidenced by the presence of stir-fried dishes, soups, and stews. In the south where grilling and barbecuing are more prevalent, there are distinctive Thai, Cambodian, and Indian influences that lead to much spicier foods. However, the one charming characteristic shared by the Vietnamese throughout the country, is the way we enjoy serving food at the table: we wrap or roll morsels of cooked food in rice paper or fresh lettuce, along with cooling herbs, then dip the bundles in spicy sauces and eat them by hand.

A typical Vietnamese pantry include *nuoc mam*, or fish sauce, which lends saltiness to a dish; fiery chile peppers; and a prodigious amount of fresh herbs—among them, fragrant lemongrass, refreshing mint, peppery basil, coriander, and ginger. Sour seasonings such as tamarind, lime juice, lime leaves, and green unripened fruits also figure prominently. Seafood, poultry, and pork are the most highly used main ingredients; beef is still considered a luxury meat because of land scarcity, while lamb or veal are not traditionally used in Vietnamese cooking.

Vietnamese cooking takes into consideration the modern demands for freshness, flavor, and healthful eating. Much of its unique taste and delicate complexity comes from the use of fresh herbs and aromatic spices. In my recipes, I have avoided toning down the heat or seasoning. I'm a firm believer that food should be so expertly seasoned that salt and pepper—or in the case of Vietnamese food, fish sauce and chiles—will not be necessary table condiments.

This proper use of seasoning is often the difference between merely good food and memorable great food. It doesn't take much to throw a dish off balance; under or over seasoning, or

an inappropriate substitution or omission of an important ingredient will do it. I feel that it is very important to get acquainted with the authentic tastes and flavors of a dish first, especially if the cuisine is new to you. So, when attempting a recipe for the first time, use the exact ingredients and measurements listed; you can always adjust to your own taste once you've become familiar with the flavors. Chances are, however, that you will love these dishes just as they are.

I share with you my very best collection of exquisite dishes in the hope they may become part of your repertoire and bring to your table, the hot, cool, and herbal—yet always exotic—flavors of my native land.

Nicole Routhier
—April, 1996

TABLE OF CONTENTS

APPETIZERS & DIPPING SAUCES

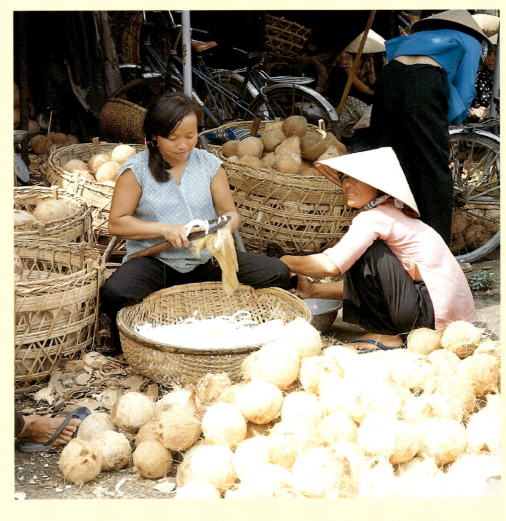

Grilled Stuffed Grape Leaves
Bo Nuong La Gno

This recipe is an adaptation of a unique and famous Vietnamese dish called Bo La Lot. La lot, *or* Piper lolot, *is an Asian aromatic. The large, heart-shaped leaf of this plant bears a striking resemblance to the grape leaf and is believed to contain a narcotic. Grilling rolls wrapped in this herb releases a unique and penetrating flavor suggestive of incense, camphor, or anise (with a hint of spiciness). Fortunately, the pleasures of eating* Bo La Lot *will not be diminished in this adaptation, which substitutes grape leaves for the rare* la lot *herb. Serve them with a traditional accompaniment of* Mam Nem *(Anchovy and Pineapple Sauce) or* Nuoc Cham *(Spicy Chile Dipping Sauce).*

SCALLION OIL
1/4 cup peanut oil
2 scallions (both green and white parts), finely sliced

Mam Nem (page 31) or *Nuoc Cham* (page 29)
24 large grape leaves, packed in brine (available at specialty food stores)

1 stalk fresh lemongrass, or 1 teaspoon finely grated lemon zest
10 ounces lean ground beef
1 medium onion, grated
4 garlic cloves, minced
1 teaspoon sugar
1 teaspoon *nuoc mam* or *nam pla* (Vietnamese or Thai fish sauce)
1 teaspoon soy sauce

1 tablespoon vegetable oil
Freshly ground black pepper
6 bamboo skewers, soaked in water for 30 minutes
2 tablespoons unsalted pan-toasted or dry-roasted peanuts, ground

Prepare the scallion oil: Heat the peanut oil in a small saucepan until hot but not smoking, about 300°F. Remove the pan from the heat and add the sliced scallions. Let the mixture steep at room temperature until completely cooled. (This oil mixture will keep stored in a tightly covered jar at room temperature for 1 week.)

Prepare desired dipping sauce and set aside with the scallion oil.

Wash the grape leaves thoroughly in cold water to remove the salt. Remove the stems, being careful not to tear the leaves. Drain.

Peel and discard the outer leaves of the lemongrass. With a sharp knife, cut off and discard the upper half of the stalk at the point where the leaves branch out. Thinly slice, then finely chop the trimmed stalk. Measure out 1 tablespoon of chopped lemongrass for immediate use. Tightly wrap the remaining portion in plastic wrap and freeze for future use.

In a bowl, mix the beef with the 1 tablespoon of lemongrass, onion, garlic, sugar, fish sauce, soy sauce, oil, and black pepper to taste. Marinate at room temperature for 30 minutes.

Place about 1 tablespoon of the mixture on the narrow end of each grape leaf. Fold the sides over, then roll up to enclose the filling, forming a neat package.

Thread 4 of the rolls on each skewer. Generously brush both sides with the scallion oil and grill over medium charcoals for 5 to 6 minutes, brushing occasionally with the scallion oil and turning once.

If you don't have a grill, heat a griddle or large skillet over medium heat. Generously brush with the scallion oil. Omit the skewers and place the rolls directly on the hot pan. Cook for about 3 minutes on each side, brushing the rolls frequently with oil, until nicely browned.

Transfer the rolls to a warm platter and brush with the remaining scallion oil. Garnish with the ground peanuts and serve with *Mam Nem* or *Nuoc Cham.*

Yield: 24 rolls

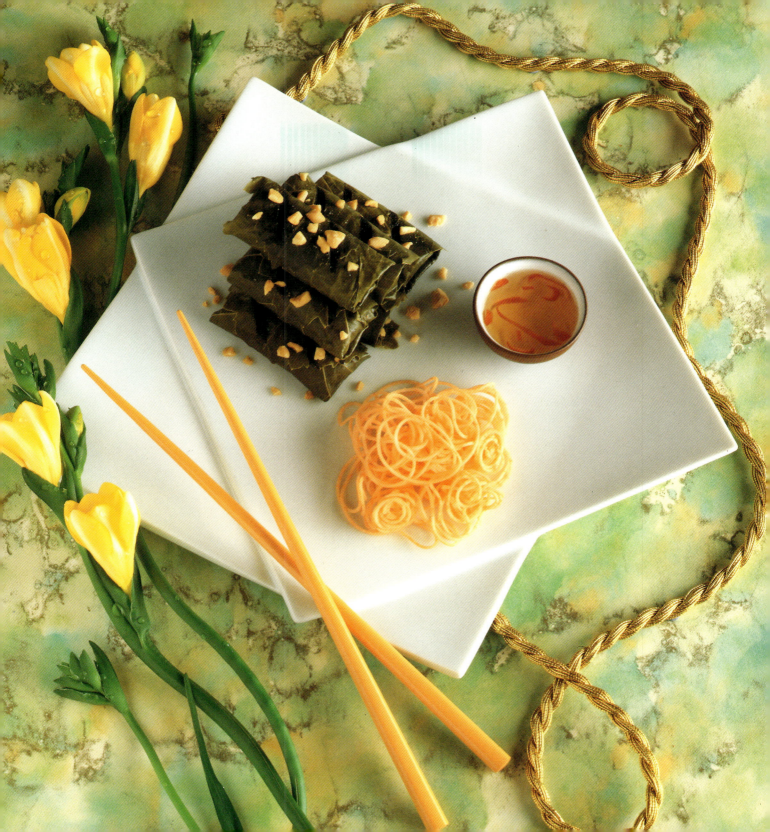

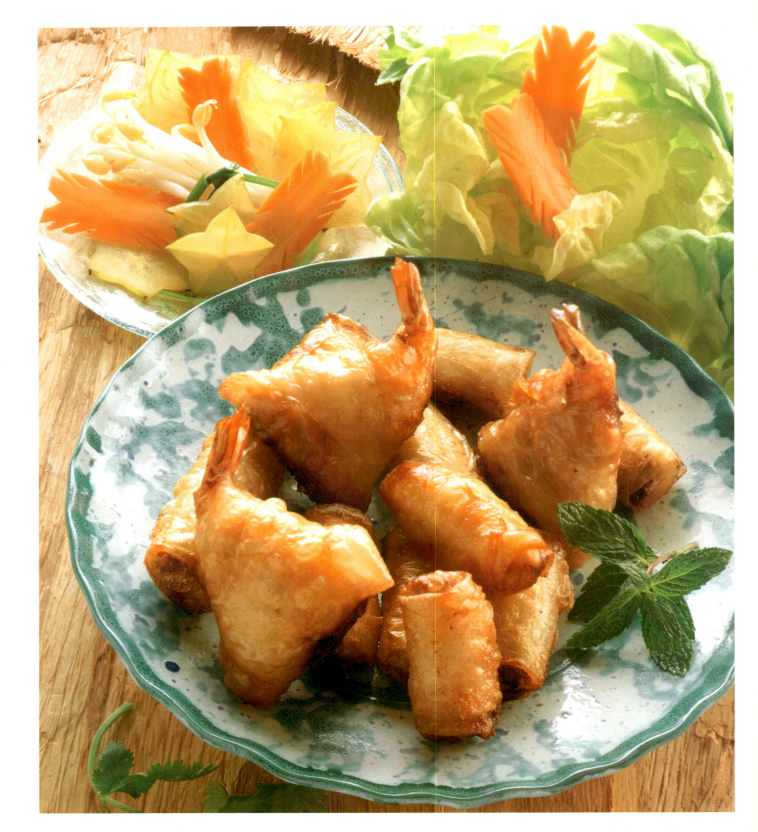

Fried Shrimp Rolls
Cha Gio Tom

In this delicious variation of the fried spring roll, a stuffing made of beef, pork, crabmeat, vegetables, and a whole shrimp is wrapped in a rice-paper round, folded into a triangular shape, and fried until crisp and golden brown.

ACCOMPANIMENTS
Nuoc Cham with Shredded
 Carrot and Daikon (page 29)
1 bunch mint
1 bunch coriander

FILLING
1 ounce cellophane (bean thread) noodles
4 ounces lean ground beef
4 ounces ground pork shoulder

4 ounces fresh or canned crabmeat,
 picked over and drained
4 shallots, minced
4 garlic cloves, minced
1/2 medium onion, minced
1 cup fresh bean sprouts
2 tablespoons *nuoc mam* or *nam pla*
 (Vietnamese fish or Thai fish sauce)
1/4 teaspoon freshly ground black pepper
1 egg

ASSEMBLING AND FRYING
1/2 cup sugar
24 rounds *banh trang* (rice-paper rounds),
 each 8 1/2 inches in diameter
24 raw medium shrimp, peeled, deveined,
 with tail sections left intact
Peanut oil, for frying

Prepare the *Nuoc Cham* with Shredded Carrot and Daikon. Wash and dry the mint and coriander leaves; set accompaniments aside.

Prepare the filling: Soak the noodles in warm water for 30 minutes. Drain, then cut them into 1-inch lengths. Combine the noodles with all of the remaining filling ingredients and, using your hands, blend together well.

Assemble the rolls: In a mixing bowl, dissolve the sugar into 4 cups of warm water. Rice paper is quite fragile, so work with only 2 sheets at a time, keeping the remaining sheets covered with a barely damp cloth to prevent curling.

Immerse 1 sheet of rice paper into the warm water. Remove and spread flat on a dry towel. Soak a second sheet of rice paper and spread it out, making sure it does not touch the other round. The rice papers will become pliable within seconds.

Fold up the bottom third of each round. Place 1/2 tablespoon of the filling in the center of the folded-over portion. Place 1 shrimp on the filling, leaving the tail section extended over the fold line. Top the shrimp with an additional 1/2 tablespoon of filling and press into a compact triangle, forming a point where the tail extends (it is important that the filling

be flat so it can be tightly and entirely wrapped). Fold the sides over to enclose the filling, then fold the remaining sides over to seal the compact triangle. The completed roll resembles a triangle with a handle. Fill the remaining wrappers in the same manner, two at a time.

Fry the rolls: Into each of two skillets, add oil to a depth of 1 inch to 1 1/2-inches and heat to 325°F. Add only a few rolls to each skillet so they do not touch or stick together. Cook the rolls over medium heat, turning often, until crisp and golden brown, about 10 to 12 minutes. Drain on paper towels. Keep them warm in a low oven while frying the remaining rolls.

Serve the shrimp rolls as an appetizer with *Nuoc Cham*, mint, and coriander leaves.

NOTE: These rolls may be cooked in advance, then reheated in a 350°F oven for about 20 minutes, or until crispy.

Yield: 24 shrimp rolls

Herb-Steamed Mussels
Hen Hap

Large snails are traditionally used in this recipe, but since most Westerners frown at the idea of eating snails, I have substituted fresh mussels instead. The vibrant flavors of chile, garlic, lime, lemongrass, and basil meld together wonderfully, making this a memorable appetizer.

2 1/2 pounds large mussels
1 tablespoon peanut oil
1 tablespoon minced garlic (about 6 medium cloves)

2 stalks fresh lemongrass, cut into 2-inch lengths, then crushed
1/2 cup firmly packed fresh Thai basil leaves or regular sweet basil

2 Kaffir lime leaves (optional)
1/3 cup dry white wine
2 small fresh Thai or serrano chile peppers, finely minced

Scrub, wash, and debeard the mussels. Drain well, removing and discarding any mussels that have opened.

In a large soup pot, heat the oil over medium-high heat. Add the garlic, lemongrass, basil, and lime leaves, and stir-fry until fragrant, about 1 minute.

Add the mussels and stir to coat them with the oil. Add the wine and chile peppers. Cover and bring to a boil over high heat. Steam the mussels for about 5 minutes, shaking the pan frequently so they are evenly cooked. Turn off the heat and let the mussels sit, covered, for 2 minutes. Remove the lid and discard any mussels that have not opened.

Transfer the mussels to a large serving bowl and serve immediately.

Yield: 4 to 6 servings

Shrimp Chips
Banh Phong Tom

Shrimp chips are easy and fun to cook and are usually served with drinks as an hors d'oeuvre or used as a "scoop" for eating salads. When deep-fried, they swell within seconds of entering the oil to double or triple their original size. Shrimp chips are sold by the box and resemble dehydrated potato chips.

Dried shrimp chips

Vegetable oil, for frying

In a wok or small heavy saucepan, add oil to a depth of 2 inches and heat to 350°F. Add 2 or 3 chips at a time (1 at a time if large) and keep them immersed in the oil with a chopstick or slotted spoon until puffy, about 10 to 15 seconds. Immediately turn over and cook on the other side for 10 to 15 seconds longer. Remove and drain on paper towels.

These feather-light crackers can be served immediately or stored at room temperature in an airtight plastic container for up to 4 days. If they get soggy, open the container lid and let the chips "breathe" for awhile, until they become crispy again.

NOTE: If the chips start browning too quickly, reduce the heat and wait until the oil cools down a bit before adding any more. Otherwise, you will have chips that are burned and not sufficiently puffed.

Spiced Pork in Lettuce Cups
Banh Thap

Years ago I would patronize an excellent Vietnamese restaurant in New York's Chinatown.
This appetizer was one of my favorites on the menu because it was so delicious yet very simple to re-create.
Fortunately, although the restaurant no longer exists, I still have this dish to remember it by.

3 stalks fresh lemongrass
2 fresh Thai or serrano chile peppers, coarsely chopped
1 tablespoon minced garlic (about 6 medium cloves)
1 tablespoon sugar
1 pound lean ground pork

2 tablespoons *nuoc mam* or *nam pla* (Vietnamese or Thai fish sauce)
4 tablespoons peanut oil
8 scallions (green and white parts), finely sliced
Freshly ground black pepper

$1/3$ cup unsalted pan-toasted or dry-roasted peanuts, coarsely ground
2 dozen small Boston lettuce leaves, taken near the hearts
Fresh coriander sprigs, for garnish
Fresh mint leaves, for garnish

Peel and discard the outer leaves of the lemongrass. Cut off and discard the upper half of stalks at the point where the leaves branch out. Thinly slice the remaining stalks.

Process the lemongrass, chiles, garlic, and sugar in a food processor until finely ground.

Transfer the mixture to a mixing bowl, then add the pork, fish sauce, and 1 tablespoon of the peanut oil. Blend well. Cover and refrigerate for 30 minutes.

Heat 2 tablespoons of oil in a wok or large skillet set over medium-low heat. Add the scallions and stir-fry until lightly browned, about 2 minutes. Remove and drain on paper towels. Set aside.

Add the remaining 1 tablespoon of oil to the skillet. Increase the heat to high, add the pork, and stir-fry, breaking up any lumps with a wooden spoon, until the meat turns a light golden brown, about 3 minutes. Transfer to a serving platter and sprinkle with the scallion pieces, black pepper, and ground peanuts.

Arrange the naturally-formed lettuce cups on a large platter. Top each leaf with a spoonful of spiced pork and a few sprigs of coriander and mint leaves. Roll each leaf into a roll to be eaten by hand.

Yield: 24 hors d'oeuvres

Fresh Summer Rolls
Goi Cuon

This is nothing more than a Vietnamese salad with pork and shrimp rolled up in rice papers. Aromatic herbs in these traditional rolls give an incredibly refreshing taste. They may be served with either Peanut Sauce or Nuoc Cham with Shredded Carrot and Daikon.

Peanut Sauce (page 30) or *Nuoc Cham* with Shredded Carrot and Daikon (page 29)

2 ounces *bun* (thin rice vermicelli) or 1/2 bundle *somen* (Japanese alimentary paste noodles), prepared according to directions on page 60

8 raw medium shrimp

12 ounces fresh bacon (pork belly) or boneless pork loin, in one piece

1 large carrot, shredded

1 teaspoon sugar

8 rounds *banh trang* (rice-paper rounds), each 8 1/2 inches in diameter

4 large red leaf or Boston lettuce leaves, thick stem ends removed and leaves halved

1 cup fresh bean sprouts

1/2 cup mint leaves

16 sprigs Chinese chives, trimmed to 5-inch lengths (optional)

1/2 cup coriander leaves

1 tablespoon unsalted pan-toasted or dry-roasted peanuts, ground

Prepare desired dipping sauce and noodles and set aside.

Boil the shrimp for 3 minutes; refresh under cold water. Shell, devein, and halve lengthwise. Set aside.

Cook the fresh bacon in boiling salted water for 20 minutes; refresh in cold water. Thinly slice into 1 x 2-inch pieces. In a bowl, combine the shredded carrot with the sugar; let stand for 10 minutes to soften.

Have a basin of warm water ready to moisten the rice papers. Work with only 2 sheets of rice paper at a time and keep the remaining sheets covered with a barely damp cloth to prevent curling. Immerse each sheet individually into the warm water. Quickly remove and spread out flat on a dry towel without letting the sheets touch one another. The rice paper will become pliable within seconds.

Lay one piece of lettuce over the bottom third of the rice paper. On top of the lettuce, place 1 tablespoon of noodles, 1 tablespoon of the shredded carrot, a few pieces of pork, bean sprouts, and several mint leaves. Roll up the paper into a partial cylinder. Fold both sides of the paper over the filling.

Lay 2 shrimp halves, cut side down, along the crease. Tuck 2 chive sprigs under the shrimp at one end, leaving about 1 inch of the chives extending over the fold line. Place several coriander leaves next to the shrimp row. Finish rolling the paper into a complete cylinder to seal. Place the rolls on a plate covered with a damp towel so they will stay moist as you fill the remaining wrappers.

Pour the dipping sauce into small individual bowls and sprinkle with the ground nuts. Dip the roll in the sauce as you eat.

NOTE: These rolls can be prepared a few hours in advance, covered with a damp towel or plastic wrap, and kept at room temperature until needed.

Yield: 8 rolls or 4 servings

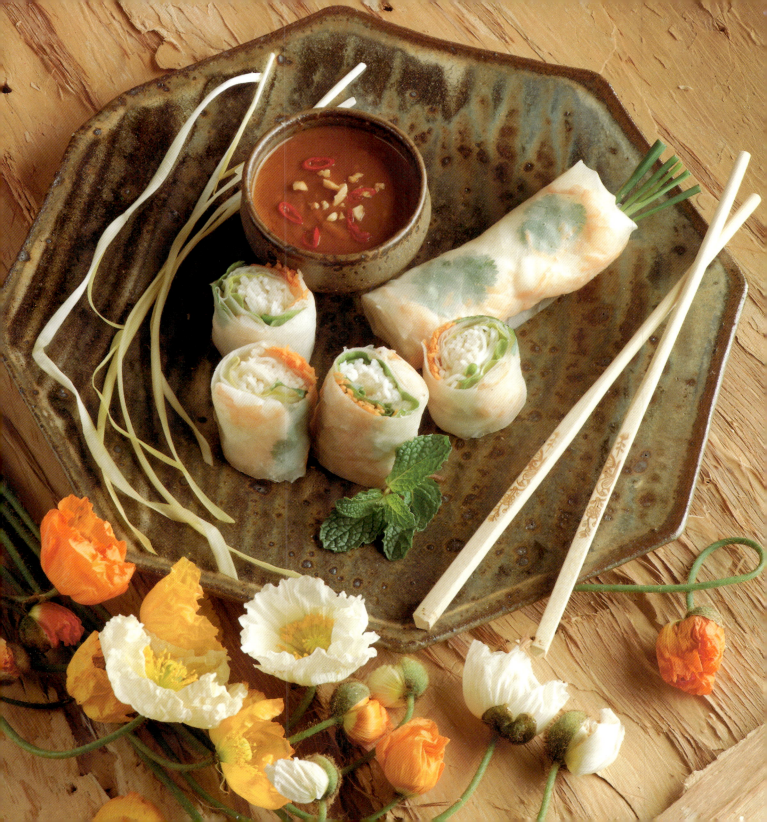

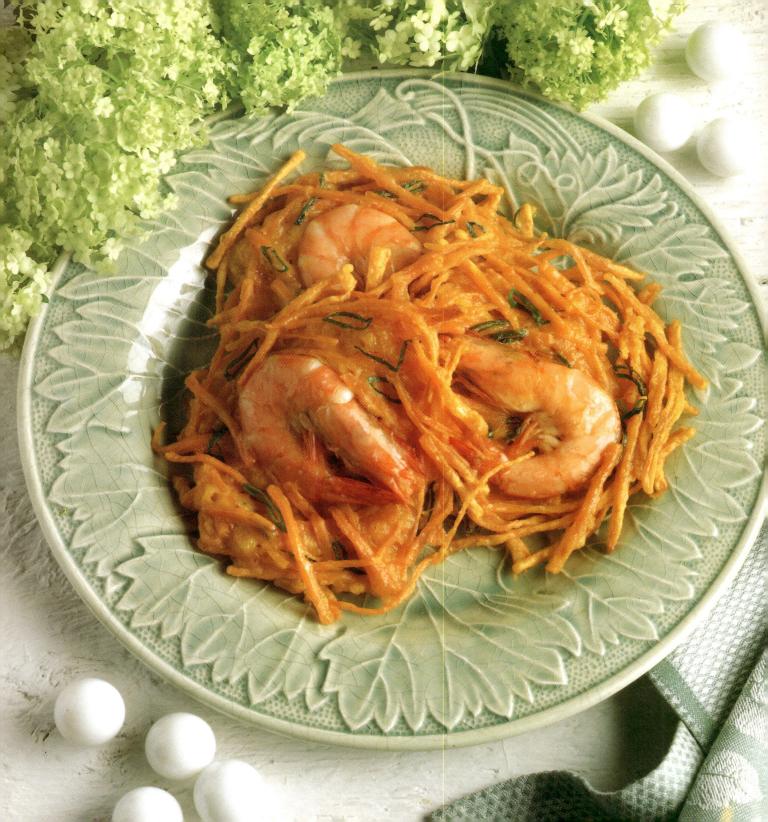

Shrimp & Sweet Potato Cakes
Banh Tom

Also called Banh Cong, *these delicious shrimp cakes are always served wrapped in crisp lettuce leaves with fresh herbs and dipped in* Nuoc Cham. *If you are fortunate enough to find fresh prawns, you can leave the 16 of them unshelled to place on top of the batter. You may also substitute Idaho potatoes for sweet potatoes.*

Nuoc Cham with Shredded
 Carrot and Daikon (page 29)

VEGETABLE PLATTER
1 large head of Boston or other soft
 lettuce, separated into individual leaves
1 bunch scallions, cut into 2-inch lengths
1 cup coriander leaves
1 cup mint leaves
1 cup Thai basil or regular sweet basil
 leaves

1 cucumber, peeled in alternating strips,
 halved lengthwise, and sliced thinly
 crosswise
4 ounces fresh bean sprouts
 Prepared pickled shallots (optional)

SHRIMP AND SWEET POTATO CAKES
24 raw medium shrimp (about 1 1/2
 pounds)
1 tablespoon *nuoc mam* or *nam pla*
 (Vietnamese or Thai fish sauce)

2 garlic cloves, minced
 Freshly ground black pepper
2 cups cake flour
2 tablespoons sugar
1 tablespoon salt
1 teaspoon baking powder
3/4 teaspoon turmeric
1 large sweet potato (about 1/2 pound)
2 scallions (both green and white parts),
 finely sliced
 Vegetable oil, for deep-frying

Prepare the *Nuoc Cham*; set aside.

Prepare the vegetable platter: On a large platter, decoratively arrange all of the ingredients in separate groups. Set aside.

Shell and devein the shrimp, leaving the tails attached on 16 of the shrimp. In a bowl, combine the tailed shrimp, fish sauce, garlic, and black pepper to taste. Mix well and refrigerate. Finely chop the shrimp without tails. Using the back of a cleaver, mash the shrimp, but do not reduce to a paste. It is important to retain some of their texture. Set aside.

In a large mixing bowl, sift together the flour, sugar, salt, baking powder, turmeric, and black pepper. Make a well in the center and pour in 1 1/2 cups of cold water, stirring constantly with a whisk until the batter becomes very smooth and takes on the consistency of thick cream.

Pare the sweet potato, slice it paper-thin, then shred it into very thin strands. Add the shredded potato, scallions, and mashed shrimp to the batter; mix well.

In a large heavy skillet, add oil to a depth of 1 inch and heat until very hot but not smoking.

Meanwhile, spoon about 2 heaping tablespoons of the potato mixture onto a saucer and lightly press a whole shrimp into the center. Holding the saucer close to the surface of the oil, gently push the cake into the oil with a spoon. Fry the cakes, 3 or 4 at a time, for about 2 minutes, spooning hot oil over each cake. Regulate the heat so the cakes cook evenly without burning. Carefully turn the cakes, shrimp side down, and cook for another 2 minutes until crisp and golden brown. Remove from the skillet and drain on paper towels. Keep warm in a low oven while you fry the remaining cakes.

Arrange the cakes, shrimp side up, on a warm platter. To eat, diners place a piece of the shrimp cake on a leaf of lettuce, then top with desired ingredients from the vegetable platter along with some shredded carrot and daikon from the sauce. The bundle is then rolled up, dipped in *Nuoc Cham*, and eaten by hand.

Yield: 16 cakes

Stuffed Shrimp in Coconut Batter
Tom Ngnoi Chien

Every Vietnamese cook has his or her own version of fried shrimp, but my mother's version is indisputably the best.
She combined elements of Vietnamese and Laotian cooking to come up with lively morsels of stuffed shrimp dipped in a thin coconut-flavored batter,
which were then fried. She served these addictive little hors d'oeuvres with a piquant dipping sauce.

Nuoc Cham (page 29)
24 raw medium shrimp (about 1 pound)
1 teaspoon cracked black peppercorns
1 teaspoon minced garlic (about 2
 medium cloves)
2 tablespoons finely chopped coriander
 leaves
1/4 pound ground pork

4 teaspoons *nuoc mam* or *nam pla*
 (Vietnamese or Thai fish sauce)
2 tablespoons finely chopped jicama or
 water chestnuts
1 teaspoon sugar
1 teaspoon cornstarch

BATTER
1/3 cup rice flour
1/4 cup all-purpose flour
1/4 teaspoon salt
1/4 teaspoon baking soda
3/4 cup fresh or canned coconut milk
2 teaspoons distilled white vinegar
 All-purpose flour, for dredging
 Vegetable oil, for deep-frying

Prepare the *Nuoc Cham*; set aside.

Peel and devein the shrimp. To butterfly the shrimp, use a small paring knife to slit each shrimp down its curved side, being careful not to cut all the way through the meat. Spread each shrimp wide open. Set aside.

Prepare the filling: Place the peppercorns, garlic, and coriander in a mortar or spice grinder and pound or grind to a coarse paste. Transfer the paste to a mixing bowl and add pork, fish sauce, jicama, sugar, and cornstarch. Mix by hand until thoroughly blended. Cover and refrigerate until needed.

Prepare the batter: Combine the rice flour, all-purpose flour, salt, and baking soda in a mixing bowl. Make a well in the center and add to it the coconut milk and vinegar. With a whisk, gradually draw the flour into the well and blend until the mixture is smooth. Cover and refrigerate until needed.

Stuff the shrimp: Spread about 1 teaspoon of filling onto each butterflied shrimp, being careful to press the filling and shrimp together so they adhere to each other. Continue stuffing until all the shrimp and filling are used up. (If not cooking immediately, arrange the stuffed shrimp on a large platter, cover, and refrigerate until ready to use.)

To cook, coat both sides of each shrimp with flour, gently shaking off the excess. Arrange in a single layer on a platter. Remove batter from refrigerator and whisk thoroughly just before using.

In a large heavy skillet, add oil to a depth of 1 inch and heat to 350°F. Holding a shrimp by the tail end, dip it into the batter, then carefully add it to the hot oil, stuffed side down. Fry the shrimp, a few at a time, until crisp and golden, about 2 minutes. Using tongs, turn the shrimp over and cook for another 30 seconds. Transfer the cooked shrimp to a platter lined with paper towels and keep warm in a 200°F oven while you cook the rest. Serve immediately with *Nuoc Cham*.

Yield: 24 hors d'oeuvres

Grilled Beef Jerky
Thit Bo Kho

This Vietnamese-style beef jerky is delicious served with drinks or as a snack with glutinous rice.
It is also an ingredient in Green Papaya Salad.

1 pound lean bottom round or sirloin, in one piece, about 6 inches in diameter
2 stalks fresh lemongrass

2 small Thai or serrano chile peppers, seeded
2 1/2 tablespoons sugar or honey

1 tablespoon *nuoc mam* or *nam pla* (Vietnamese or Thai fish sauce)
3 tablespoons light soy sauce

Cut the beef across the grain into very thin 3 x 3-inch slices.

Remove the outer leaves of the lemongrass, and with a sharp knife, cut off and discard the upper half of the stalks at the point where the leaves branch out. Thinly slice the remaining stalks.

Combine the chiles and sugar in a mortar and pound to a fine paste. Add the lemongrass, fish sauce, and soy sauce and stir to blend. (If using a blender, combine all of these and blend to a very fine paste.) Spread the paste over the beef pieces, coating both sides. Let marinate for 30 minutes.

Spread out each slice of marinated beef on a large, flat wire rack or baking sheet. Let the slices stand in the sun until both sides are completely dried, about 12 hours. (You can also place a rack on a jelly roll pan and let the beef dry in the refrigerator for 2 days.)

Grill the beef over a medium charcoal fire or transfer the rack from the refrigerator to the middle of a preheated 400°F oven and bake the slices until brown and crisp, about 10 minutes. Serve with glutinous rice.

NOTE: The cooked meat may be kept for up to 1 week in a covered jar at room temperature.

Yield: 4 servings

Boiled Shrimp & Pork Dumplings
Banh Bot Loc

These delicious dumplings come from the central region of Vietnam. Tapioca starch lends an interesting, chewy texture to these snacks.

Scallion oil (page 12), double the
recipe amount
Nuoc Cham with Shredded
Carrot and Daikon (page 29)
4 ounces ground pork
4 ounces raw medium shrimp, peeled
deveined, and coarsely chopped
2 large garlic cloves, minced

1 1/2 tablespoons *nuoc mam* or *nam pla*
(Vietnamese or Thai fish sauce)
1/8 teaspoon sugar
Freshly ground black pepper
2 dried Chinese mushrooms
1 1/2 teaspoons dried tree ear
mushrooms
2 tablespoons vegetable oil

2 large shallots, chopped
1 teaspoon tomato paste
1/4 cup chopped bamboo shoots, water
chestnuts, or jicama
1 cup tapioca starch
1/4 teaspoon salt
32 fresh coriander sprigs

Prepare the scallion oil and *Nuoc Cham*; set aside.

In a mixing bowl, combine the ground pork, shrimp, garlic, fish sauce, sugar, and black pepper to taste. Mix well. Cover and refrigerate.

Soak the two types of mushrooms in hot water for 30 minutes. Squeeze the mushrooms dry; remove and discard the stems. Coarsely chop the mushroom caps.

Heat 1 tablespoon of the oil in a wok or skillet over high heat. Add the shallots and stir-fry for 30 seconds. Add the tomato paste and stir for 1 minute. Add the pork and shrimp mixture and stir-fry for 3 minutes. Add the mushrooms and bamboo shoots and cook until heated through. Transfer the filling to a dish to cool. (The recipe may be prepared to this point half a day in advance. Cover and refrigerate.)

Prepare the dough: Combine the tapioca starch and salt in a mixing bowl. In a small saucepan, combine the remaining 1 tablespoon of oil with 1/2 cup plus 2 tablespoons water. Bring to a rapid boil. Gradually pour the liquid over the tapioca starch. Working quickly, use chopsticks or a fork to stir the mixture until it forms a sticky mass. Cover the dough and let stand for 15 minutes, or until cool enough to handle. Lightly oil a work surface and knead the dough for 5 minutes, or until smooth.

Divide the dough into 2 equal parts. Work with half of the dough at a time; keep the other half covered with a damp cloth. Dust a work surface with flour. Knead each half of the dough for a few more minutes until very smooth. Roll the dough with your hands to form a long rope about 1 inch in diameter. Cut each rope into 16 equal portions.

Cover the dough pieces with a damp cloth as you work. Working with 1 portion at a time, roll out each piece of dough into a 3 1/4-inch circle. Use a 3-inch cookie cutter to make a perfect round. To form each dumpling, place a heaping teaspoon of the filling on one half of the dough circle. Place 1 coriander sprig on top of the filling. Fold the dough over the filling and pinch the edges together to seal. Set the dumpling on an oiled tray and keep covered with a damp cloth. Continue until the dough portions, filling, and coriander are used up.

Bring a large pot of water to a boil. With a large bowl of cold water and the scallion oil placed next to the stove, add the dumplings to the boiling water in batches of 6 to 8. Cook over medium heat for 2 minutes. Use a wire mesh sieve or slotted spoon to remove the cooked dumplings. Drop them into the bowl of cold water and let them soak for 1 minute, or until they turn translucent. Transfer the dumplings from the water to the oil, then soak them until they are lukewarm, about 1 minute. Serve on a platter along with *Nuoc Cham* with Shredded Carrot and Daikon.

Yield: 32 dumplings

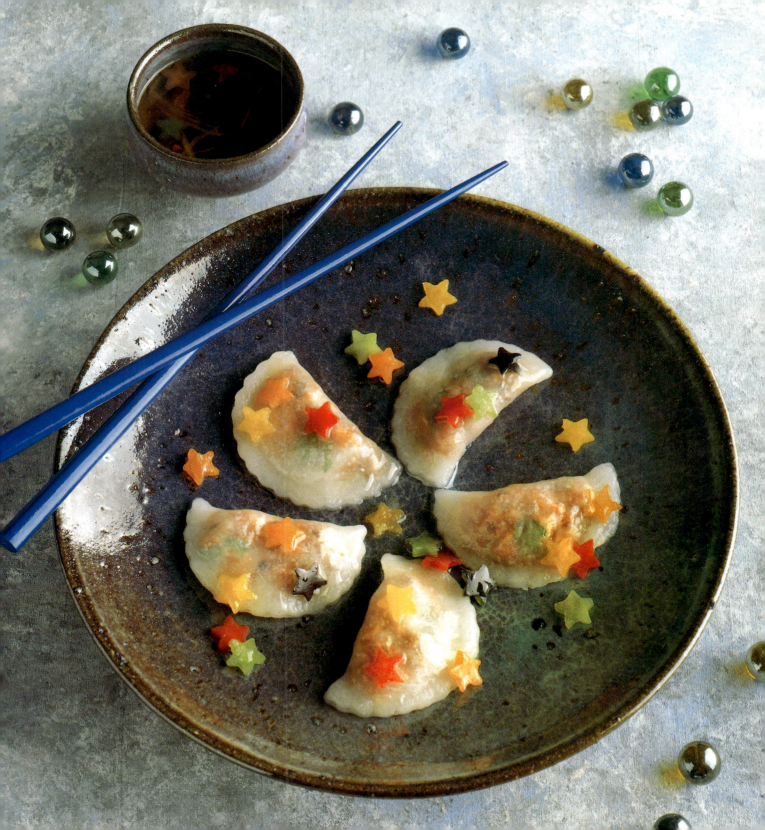

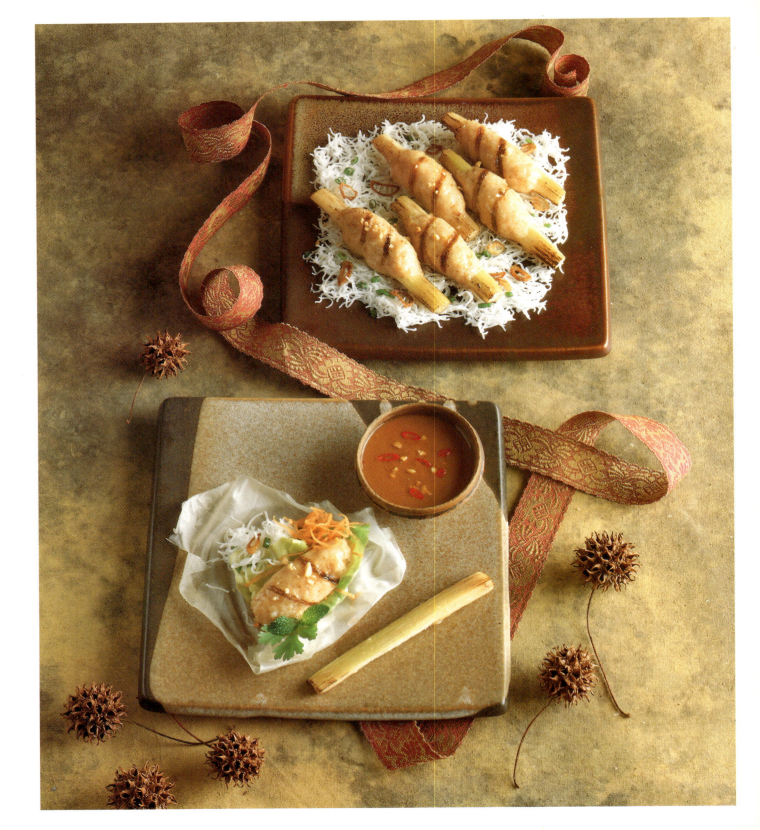

Barbecued Shrimp Paste on Sugar Cane
Chao Tom

*Although this dish can be baked in an oven, I strongly suggest you grill it over charcoal, for the result is
far superior. The dish may be prepared over two consecutive days. Prepare the dipping sauce and condiments on the first day.
The vegetable platter and shrimp paste can be assembled the following day. Fresh sugar cane may be obtained at
Caribbean markets; canned sugar cane is available at Asian grocery stores.*

I tablespoon Roasted Rice Powder (page 28)
Scallion oil (page 12)
1/2 cup vegetable oil
1/2 cup thinly sliced shallots (about 8 large shallots)
I tablespoon salt
I pound raw shrimp, shelled and deveined
4 ounces pork fat
6 garlic cloves, crushed

6 shallots, crushed
2 ounces rock sugar crushed to a powder, or I tablespoon granulated sugar
4 teaspoons *nuoc mam* or *nam pla* (Vietnamese or Thai fish sauce)
Freshly ground black pepper
Peanut Sauce (page 30)
Prepared vegetable platter (page 21)
8 ounces *banh trang* (rice-paper rounds), each 6 1/2 inches in diameter

12-inch piece fresh sugar cane, or I can (12 ounces) sugar cane packed in light syrup, drained
12 (8 1/2-inch) bamboo skewers, soaked in hot water for 30 minutes
Vegetable oil, for shaping shrimp paste
8 ounces *banh hoi* (extra-thin rice vermicelli)
I tablespoon unsalted pan-toasted or dry-roasted peanuts, ground

Prepare the Roasted Rice Powder and scallion oil; set aside.

Heat the vegetable oil in a small saucepan until hot but not smoking, about 300°F. Add the thinly sliced shallots and fry over medium heat until crisp and golden brown, about 5 minutes. Do not overcook. Immediately remove with slotted spoon and drain on paper towels. Reserve oil for another use.

Sprinkle the salt over the shrimp and let stand for 20 minutes, then rinse thoroughly with cold water. Drain and squeeze them between your hands to remove excess water. Dry the shrimp thoroughly with paper towels, then coarsely chop.

Boil the pork fat for 10 minutes. Drain and finely dice. In a food processor, combine the shrimp, garlic, crushed shallots, and sugar. Process until the shrimp paste pulls away from the sides of the container, stopping when necessary to scrape down the sides. The paste should be very fine and sticky.

Add the pork fat, Roasted Rice Powder, fish sauce, and black pepper to taste. Pulse briefly, only enough to blend all of the ingredients. Cover and refrigerate.

Meanwhile, prepare the Peanut Sauce and the vegetable platter. Cover the rice papers with a damp towel and a sheet of plastic wrap; keep at room temperature until needed.

Peel the fresh sugar cane and cut crosswise into 4-inch sections. Split each section lengthwise into quarters. (If using canned sugar cane, split each section lengthwise in half only, then thread 2 pieces lengthwise onto a skewer.)

Pour about 1/4 cup of oil into a small bowl and oil your fingers. Pick up and mold about 2 tablespoons of the shrimp paste around and halfway down a piece of fresh sugar cane. Leave about 1 1/2 inches of the sugar cane exposed to serve as a handle. (If using canned sugar cane, there is no need to leave a handle. The skewers will serve as handles.) Press firmly so that the paste adheres to the cane. Proceed until you have used up all the shrimp paste.

Prepare a charcoal grill or preheat the oven to broil.

(continued on page 28)

Meanwhile, steam the noodles, then garnish with the scallion oil, crisp-fried shallots, and ground peanuts. Keep warm. Pour the peanut sauce into individual bowls and place the vegetable platter and rice papers on the table. Grill the shrimp paste on the sugar cane over medium coals, turning frequently, for about 8 minutes. Or broil, on a baking sheet lined with foil, about 6 inches from the heat, for 3 minutes on each side, or until browned. Transfer to a warm platter.

To serve, each diner dips a rice-paper round in a bowl of warm water to make it pliable, then places the paper on a dinner plate. Different ingredients from the vegetable platter, some noodles, and a piece of the shrimp paste, which has been removed from the sugar cane, are added. The rice paper is then rolled up to form a neat package, dipped into the sauce, and eaten by hand. The remaining sugar cane may be chewed.

NOTE: If both types of sugar cane are unavailable, use skewers. Shape the shrimp paste into meatballs and thread 3 or 4 onto each skewer.

Yield: 4 to 6 servings

Roasted Rice Powder
Thinh

Roasted rice powder is used as a flavoring and binding agent in various Vietnamese recipes. It is necessary to first soak the rice in order to obtain a deep golden color after roasting. Soaking also makes the rice easier to grind.

1/3 cup raw glutinous rice

Soak the glutinous rice in warm water for 1 hour. Drain. Place the rice in a small skillet over medium heat. Toast the rice, stirring constantly with chopsticks or a wooden spoon, until deep golden brown, about 15 minutes.

Transfer the rice to a spice grinder or blender and process to a fine powder (the powder should resemble sawdust). Sift the ground rice through a very fine sieve into a bowl. Discard any grainy bits.

Store the rice powder in a tightly covered jar in your refrigerator and use as needed. It will keep for up to 3 months.

Yield: 1/3 cup

Spicy Chile Dipping Sauce
Nuoc Cham

Of all the sauces, Nuoc Cham *is perhaps the most indispensable at the Vietnamese table, where it serves somewhat the same function as salt and pepper do in the West. It is a delightfully tangy piquant seasoning. Like most Vietnamese sauces, it includes* nuoc mam, *the traditional Vietnamese fish sauce responsible for the unique, well-defined personality of Vietnamese food.*

2 small garlic cloves, crushed
1 small fresh Thai or serrano chile
 pepper, seeded and minced

2 tablespoons sugar
2 tablespoons fresh lime or lemon juice

$1/4$ cup rice vinegar
$1/4$ cup *nuoc mam* or *nam pla* (Vietnamese
 or Thai fish sauce)

Combine the garlic, chile, and sugar in a mortar. Pound with a pestle to a fine paste.

Add the lime juice, vinegar, fish sauce, and $1/4$ cup of water. Stir to blend.

Alternatively, combine all the ingredients in a blender or food processor and process for 30 seconds, or until the sugar dissolves.

NOTE: If you wish to make additional sauce and have it handy, do as follows: Place the sugar, vinegar, and water in a saucepan and bring the mixture to a boil. Remove from the heat and let cool. Add the lime juice and fish sauce.

This sauce may be stored in a tightly closed bottle or jar and refrigerated for 2 or 3 months. Each time you need *Nuoc Cham*, just crush some fresh chiles and garlic and add as much sauce as needed.

Yield: 1 cup

VARIATION: Some people like to garnish this sauce with shredded carrots and daikon (or white turnip). This can also serve as a quick substitute for pickled carrots when they are indicated in a recipe.

Nuoc Cham with Shredded Carrot and Daikon

1 small carrot, shredded
1 small daikon or white turnip, peeled and shredded
1 teaspoon sugar
1 cup *Nuoc Cham*

Toss the carrot and daikon shreds with the sugar in a small bowl. Let stand for 15 minutes to soften the vegetables. Add the dipping sauce to the softened vegetables and stir.

Yield: 1 $1/2$ cups

Peanut Sauce
Nuoc Leoc

In this recipe, I've replaced traditional tuong, *a fermented soybean sauce, and glutinous rice with the more readily available hoisin sauce and peanut butter.*

1 tablespoon peanut oil
2 garlic cloves, minced
1 teaspoon chili paste
1 tablespoon tomato paste
1/2 cup chicken broth or water

1/2 teaspoon sugar
2 tablespoons peanut butter
1/4 cup hoisin sauce
1/4 cup unsalted pan-roasted or dry roasted peanuts, ground

1 fresh Thai or serrano chile pepper, seeded and thinly sliced

Heat the oil in a small saucepan. When the oil is hot, add the garlic, chili paste, and tomato paste. Fry until garlic is golden brown, about 30 seconds. Add the broth, sugar, peanut butter, and hoisin sauce and whisk to dissolve the peanut butter. Bring to a boil. Reduce the heat and simmer for 3 minutes.

Serve warm or at room temperature, garnished with ground peanuts and chile pepper slices.

Yield: about 1 cup

Caramel Sauce
Nuoc Duong Thang

This sauce is another indispensable staple in the Vietnamese kitchen. It gives grilled meats and stews a nutty sweetness and appetizing glaze.

1/3 cup sugar

1/4 cup *nuoc mam* or *nam pla* (Vietnamese or Thai fish sauce)

4 shallots, thinly sliced
Freshly ground black pepper

Cook the sugar in a small nonstick skillet over low heat, swirling the pan constantly, until sugar turns dark brown. It will smoke slightly. Immediately remove the pan from the heat and stir in the fish sauce. (Take care, since the mixture will bubble violently.)

As soon as the bubbling settles, return the mixture to low heat and gently boil, swirling the pan occasionally, until the sugar is completely dissolved, about 3 minutes. Add the shallots and ground pepper to taste; stir to combine.

Cool the sauce before using. (If cold food is added to hot caramel sauce, the sugar will harden instantly and you will end up with a dish full of candy chips.)

Yield: 1/3 cup

Anchovy & Pineapple Sauce
Mam Nem

This is by far the most intricate of Vietnamese sauces. What makes it so special is the use of mam nem, *a sauce prepared from ground fresh anchovies and salt and fermented over a period of time. Traditionally,* mam nem *is served as a dipping sauce for barbecued or fried fish. In general, it goes well with grilled foods. Use only fresh pineapple and remember to shake the bottle of anchovy sauce thoroughly before using. Anchovy cream may be substituted.*

1 cup minced fresh pineapple
3 tablespoons *mam nem*
 (anchovy sauce)
2 garlic cloves, crushed

1 fresh Thai or serrano chile pepper,
 seeded
1 tablespoon sugar
3 tablespoons fresh lemon juice

1 1/2 teaspoons rice vinegar or distilled
 white vinegar
3 tablespoons *nuoc mam* or *nam pla*
 (Vietnamese or Thai fish sauce)

Over a bowl, squeeze the pineapple between your hands to extract as much juice as possible. Combine the pulp and juice and set aside.

Into a bowl, strain the anchovy sauce through a very fine sieve, pressing on the solids with a spoon to extract all of the liquid. Discard the solids.

In a mortar, pound or crush the garlic, chile, and sugar to a fine paste in a bowl. Stir in the pineapple mixture, strained anchovy sauce, lemon juice, vinegar, and fish sauce. Stir to blend.

Yield: 1 1/3 cups

SALADS

Green Papaya Salad
Goi Du Du

In Vietnam, this salad is eaten as a snack rather than as a full dish and is usually accompanied by glutinous rice. For an authentic taste, use an unripe papaya, which is available in Southeast-Asian markets or Caribbean grocery stores. Green mango makes an excellent substitute.

Grilled Beef Jerky (page 23)
2 garlic cloves, minced
1/2 teaspoon salt
2 teaspoons sugar

1/4 cup distilled white vinegar
1 tablespoon chile sauce (*sriracha* or *sambal oeleck*) or Tabasco sauce

1 green papaya (about 1 1/2 pounds), peeled, seeded, and finely shredded
1 medium carrot, finely shredded
1 cup finely shredded coriander leaves

Prepare the Grilled Beef Jerky. Using scissors, cut the beef pieces into thin strips. Set aside.

Combine the garlic, salt, sugar, vinegar, and chile sauce in a bowl. Stir to blend. Set the dressing aside.

In a large salad bowl, combine the shredded papaya, carrot, beef strips, and coriander. Add the dressing and toss well.

Transfer the salad to a serving platter.

NOTE: The prepared beef jerky sold at Chinese and Vietnamese food markets can be substituted in this recipe.

Yield: 4 to 6 servings

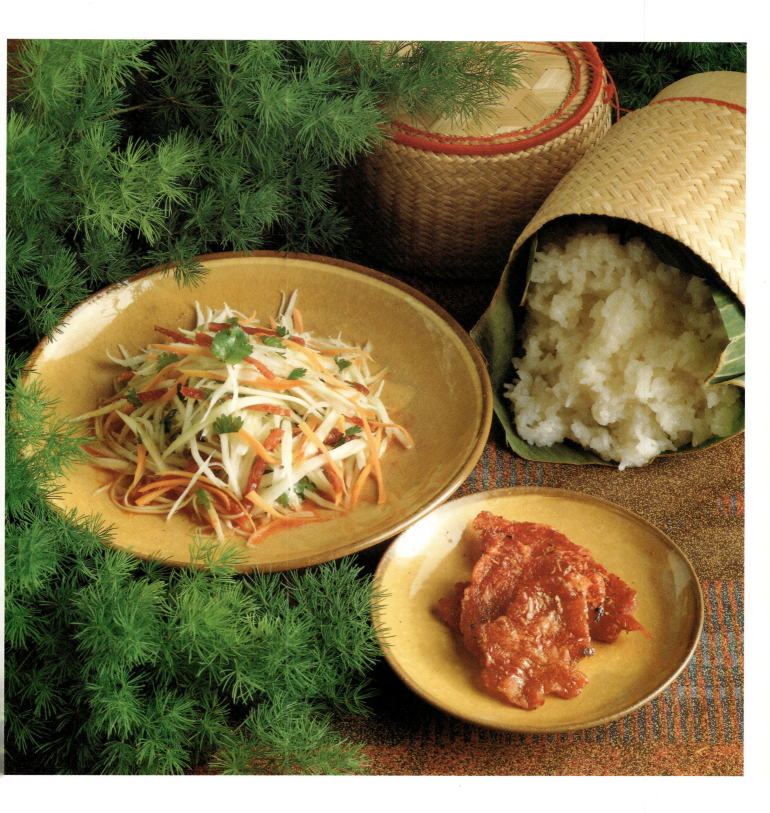

Minted Cabbage & Chicken Salad
Ga Xe Phay

In Vietnam, Ga Xe Phai is as popular as coleslaw is in the United States. Like most Vietnamese salads, this one uses very little oil and may be served with shrimp chips. In my family, this dish is almost always served along with Chicken and Cellophane Noodle Soup. My mother would remove the cooked hen from the broth, along with the gizzards and liver, shred everything, and then add the pieces to the salad and the soup.

2 fresh Thai or serrano chile peppers, seeded and minced
3 garlic cloves, minced
2 tablespoons sugar
1 tablespoon rice vinegar
3 tablespoons fresh lime juice

3 tablespoons *nuoc mam* or *nam pla* (Vietnamese or Thai fish sauce)
3 tablespoons vegetable oil
1 medium onion, thinly sliced
Freshly ground black pepper
2 cups shredded cooked chicken

4 cups finely shredded white cabbage
1 cup shredded carrot
1/2 cup shredded fresh mint
Coriander sprigs, for garnish

In a bowl, combine the chiles, garlic, sugar, vinegar, lime juice, fish sauce, oil, onion, and black pepper to taste. Let the dressing stand for 30 minutes.

In a large mixing bowl, combine the shredded chicken, cabbage, carrot, and mint. Drizzle the salad with the dressing and toss well.

Transfer the salad to a serving platter and garnish with the coriander sprigs. Sprinkle with additional black pepper and serve with shrimp chips, if desired.

Yield: 4 to 6 servings

Mixed Vegetable & Grapefruit Salad
Goi Buoi

Unlike Western leafy green salads, Vietnamese salads are based on shredded raw vegetables and other ingredients, cooked or uncooked, that are mixed together. This beautiful, confetti-like salad, with its crunchy vegetables, fresh grapefruit, cooling herbs and nutty sesame seeds, is an explosion of textures and flavors. Try it as an appetizer or as a side dish to grilled meats.

Peanut oil, for frying
1/2 cup thinly sliced shallots (about 8 large shallots)

DRESSING
4 fresh Thai or serrano chile peppers, minced
1 tablespoon minced garlic (about 6 cloves)
1/4 cup sugar
2 tablespoons rice vinegar
1/3 cup fresh lime juice
1/3 cup *nuoc mam* or *nam pla* (Vietnamese or Thai fish sauce)

1/3 cup peanut oil
1 tablespoon dark sesame oil
Freshly ground black pepper
1 large Spanish onion, very thinly sliced

SALAD
3 cups very finely shredded white cabbage (1/2 head)
1 cup very finely shredded red cabbage (1/4 head)
2 jicamas (about 3/4 pound each), peeled and cut into thin strips

2 large pink grapefruits, skin and pith trimmed off and fruit sectioned
2 large carrots, peeled and cut into thin strips
1/2 cup finely shredded fresh mint leaves
1/2 cup coarsely chopped fresh coriander leaves
3 tablespoons sesame seeds, toasted and coarsely ground
3 tablespoons unsalted pan-toasted or dry-roasted peanuts, coarsely chopped
Fresh coriander sprigs, for garnish

Pour oil to a depth of 1/2-inch into a large skillet. Heat over medium heat until hot but not smoking, about 300°F. Add the shallots and gently fry until crisp and golden brown, about 5 minutes. Do not overcook or the shallots will develop a bitter taste. Quickly remove them with a slotted spoon and drain on paper towels. Reserve the oil for other uses.

For the dressing: Whisk together the chiles, garlic, sugar, vinegar, lime juice, fish sauce, peanut oil, sesame oil, and black pepper in a medium-size bowl. Stir in the onion, then cover and set aside until needed.

Toss the shredded white and red cabbages, jicamas, grapefruit sections, carrot, mint, and coriander in a large mixing bowl. Add the dressing, along with the sesame seeds and peanuts. Mix together thoroughly.

Transfer the salad to a serving platter and sprinkle the reserved shallots on top. Garnish with coriander sprigs and serve.

Yield: 6 to 8 appetizer or side-dish servings.

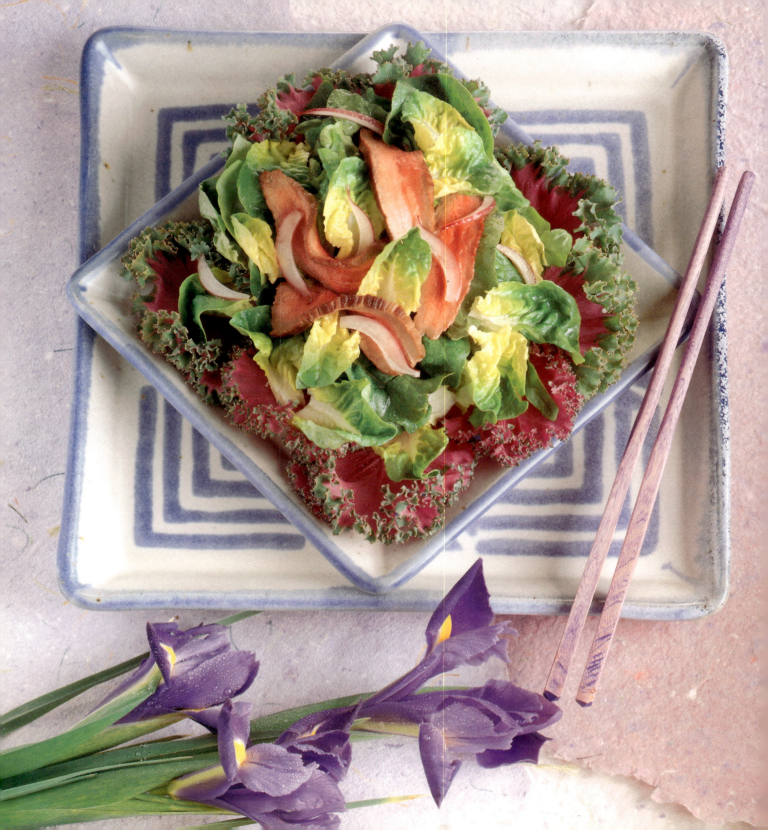

Warm Beef Salad
Bo Luc Lac

This recipe has adapted the French technique of sautéing beef as well as the use of olive oil.
It would be right at home on a French menu.

DRESSING
1 medium, red onion, peeled and cut
 into paper-thin strips
2 garlic cloves, finely minced
1/2 teaspoon sugar
1/2 teaspoon salt
1/4 cup distilled white vinegar
1/4 cup plus 2 tablespoons olive oil
 Freshly ground black pepper

BEEF
1 pound beef sirloin or other tender cut
 of meat (eye of round, filet of beef)
10 garlic cloves, minced
1 tablespoon *nuoc mam* or *nam pla*
 (Vietnamese or Thai fish sauce)
1 tablespoon soy sauce
1 teaspoon sugar
 Freshly ground black pepper

1 head chicory (*frisée*)
1/2 head of soft lettuce, such as Boston,
 red leaf, or oak leaf
1 small bunch of watercress
2 tablespoons vegetable oil

Prepare the dressing: Combine the onion, garlic, sugar, salt, vinegar, olive oil, and black pepper to taste in a large salad bowl; mix well. Set aside.

Prepare the beef: Cut the beef against the grain into thin 1 x 2-inch strips. In a bowl, combine the beef, half of the minced garlic (reserve remaining half for frying), fish sauce, soy sauce, sugar, and ground black pepper to taste. Let stand for 30 minutes.

Rinse the chicory, lettuce, and watercress. Drain and pat dry with paper towels. Add the greens to the dressing, but do not toss.

Preheat a large skillet over high heat and add the vegetable oil. Fry the remaining minced garlic until fragrant and golden. Add the beef and sauté quickly, shaking the pan, over high heat to sear, about 1 minute (the beef should be medium-rare).

Top the greens with the seared meat and toss gently. Divide the warm salad among 4 individual plates.

Sprinkle with freshly ground black pepper and serve with French bread, if desired.

NOTE: You can create your own salad combinations according to the availability of lettuce varieties, or you can substitute chicken, liver, seafood, or even fish, for the beef.

Yield: 4 servings

SOUPS

Spicy & Sour Shrimp Soup
Canh Chua Tom

This southern soup, with a nationwide appeal, is made special by the subtle combination of sweet-and-sour ingredients. Vietnamese usually include two ingredients in this soup: one is an aromatic souring herb called la kinh gioi, *or* ngo om, *sometimes called "rice-paddy herb;" the other is the spongy stem from an aquatic plant called* rau rap mong. *This soup will still taste delightful, however, even if you have difficulty obtaining these items from an Asian market. If a spicier soup is desired, pass fresh chile peppers at the table.*

2 ounces lump tamarind or 2 tablespoons tamarind concentrate
1/2 cup boiling water
1/2 pound raw shrimp, shelled and deveined
2 garlic cloves, chopped
1/4 cup plus I teaspoon *nuoc mam* or *nam pla* (Vietnamese or Thai fish sauce)
Freshly ground black pepper
2 tablespoons vegetable oil

2 shallots, thinly sliced
3 stalks fresh lemongrass, white bulb crushed and cut into 2-inch sections
I large ripe tomato, cored, seeded, and cut into wedges
2 tablespoons sugar
1/4 fresh ripe pineapple, cored, cut into 1/4-inch slices, then cut crosswise into small chunks

1/2 cup fresh or canned bamboo shoots, drained and thinly sliced
I teaspoon salt
2 fresh Thai or serrano chile peppers, minced
1/2 cup fresh bean sprouts
I scallion, thinly sliced
2 tablespoons shredded mint leaves

Soak the lump tamarind in the boiling water for 15 minutes, or until soft. Force the tamarind through a fine sieve into a small bowl. If tamarind concentrate is used, dilute it with only 1/4 cup of warm water.

Halve each shrimp lengthwise. In a bowl, combine the shrimp, garlic, I teaspoon of the fish sauce, and pepper to taste. Let stand for 30 minutes.

Heat the oil in a 3-quart saucepan. Add the shallots and lemongrass and sauté briefly, without browning. Add the tomato and sugar and cook over medium heat until slightly soft. Add the pineapple and bamboo shoots and cook, stirring, for about 2 minutes. Add 5 cups of water and bring to a boil over high heat. Stir in the tamarind liquid, salt, and the remaining 1/4 cup fish sauce. Reduce the heat to medium and simmer for 5 minutes.

Stir in the shrimp, chiles, and bean sprouts and cook for 30 seconds longer. Add the scallion and mint. Remove from the heat. Discard the lemongrass.

Ladle the soup into a heated tureen and serve at once.

NOTE: Do not overcook the shrimp or they will toughen. Catfish, red snapper, or any other firm, white-fleshed fish can replace the shrimp.

Yield: 4 to 6 servings

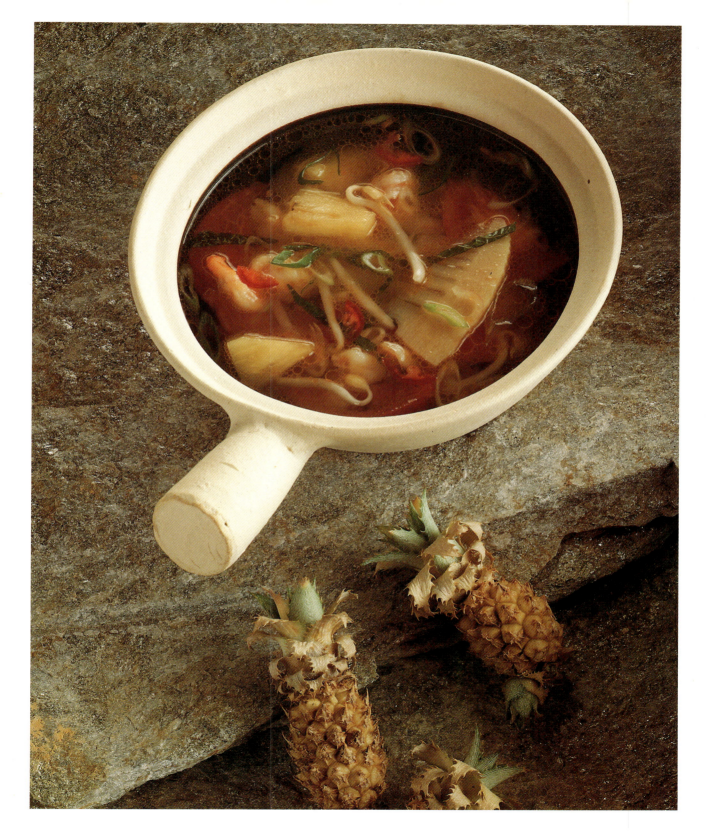

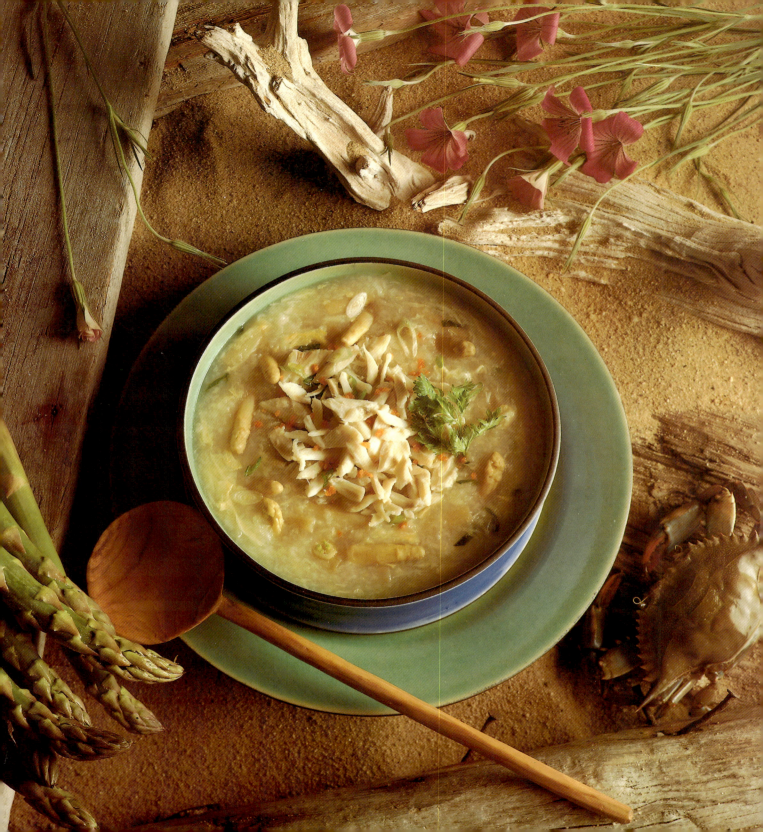

Asparagus & Crabmeat Soup
Mang Tay Nau Cua

This soup was probably created by a homesick Frenchman. White asparagus (a French import), packed in jars or cans, is used for this recipe. Crumbled, salted, duck egg yolk is also a traditional ingredient. If white asparagus is unavailable, use frozen or fresh asparagus (In the case of using fresh asparagus, add it to the broth from the very beginning and cook until tender, before adding the remaining ingredients.)

4 cups chicken broth
1 tablespoon plus 2 teaspoons *nuoc mam* or *nam pla* (Vietnamese or Thai fish sauce)
$1/2$ teaspoon sugar
$1/4$ teaspoon salt
1 tablespoon vegetable oil

6 shallots, chopped
2 garlic cloves, chopped
8 ounces fresh or canned lump crabmeat, picked over and drained
Freshly ground black pepper
2 tablespoons cornstarch or arrowroot, mixed with 2 tablespoons cold water

1 egg, lightly beaten
1 jar (15 ounces) white asparagus spears, cut into 1-inch sections with canning liquid reserved
1 tablespoon shredded coriander
1 scallion (both green and white parts), thinly sliced

Combine the broth, 1 tablespoon of the fish sauce, the sugar, and salt in a 3-quart soup pot. Bring to a boil. Reduce the heat and simmer.

Meanwhile, heat the oil in a skillet. Add the shallots and garlic and stir-fry until aromatic. Add the crabmeat, the remaining 2 teaspoons fish sauce, and black pepper to taste. Stir-fry over high heat for 1 minute. Set aside.

Bring the soup up to a boil. Add the cornstarch mixture and stir gently until the soup thickens and becomes clear. While the soup is actively boiling, add the egg and stir gently for about 1 minute. Add the crabmeat mixture and asparagus, along with the canning liquid. Lower the heat and cook gently until the soup is heated through.

Transfer the soup to a heated tureen. Sprinkle with coriander, scallion, and freshly ground black pepper.

Yield: 4 to 6 servings

Tomato & Egg Drop Soup
Canh Trung Ca Trua

This soup originated in southern Vietnam. It is probably derived from Chinese Egg Drop Soup but given a new twist when combined with tomatoes, which grow abundantly in the south. While preparing this soup one day, I experimented by including other ingredients I had on hand. The addition of lime leaves and galangal introduces a new, fresh taste and enhances all of the other flavors in the soup.

4 Kaffir lime leaves, frozen or dried (optional)

4 galangal slices, frozen or dried (optional)

2 tablespoons vegetable oil

4 shallots, thinly sliced

I teaspoon sugar

5 large ripe tomatoes, cored, seeded, and cut into wedges

5 cups chicken broth

1/4 teaspoon salt

I tablespoon *nuoc mam* or *nam pla* (Vietnamese or Thai fish sauce)

5 eggs, lightly beaten

I scallion (both green and white parts), finely sliced

I tablespoon shredded coriander

Freshly ground black pepper

If using dried lime leaves and galangal, soak them in hot water for 30 minutes. Drain.

Heat the oil in a 3-quart saucepan over moderate heat. Add the shallots and sauté until fragrant. Add the sugar and tomatoes and cook for 5 minutes, or until the tomatoes are very soft. Add the chicken broth and bring to a boil over high heat. Stir in the lime leaves, galangal, salt, and fish sauce. Reduce the heat, cover the pan, and let the broth simmer for 30 minutes.

Remove and discard the lime leaves and galangal. Bring the soup back up to a boil. While the soup is actively boiling, pour in the eggs in a thin, slow stream and stir gently for 30 seconds. Add the scallion and coriander.

Transfer the soup to a heated tureen. Sprinkle with black pepper to taste and serve hot.

Yield: 4 servings

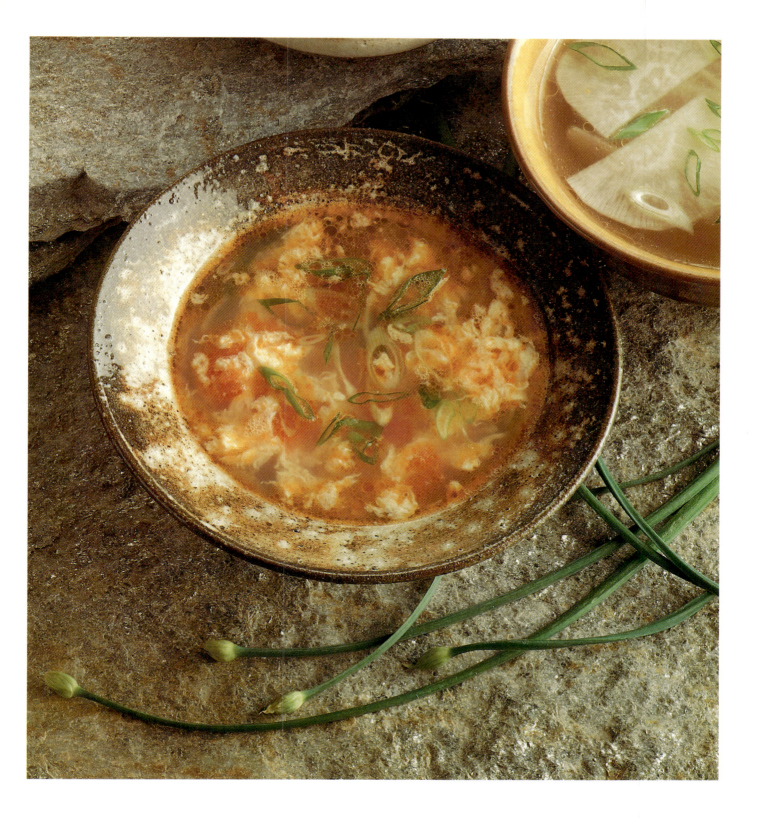

NOODLE & RICE DISHES

Hanoi Oxtail & Noodle Soup
Pho Bac

All dishes in this chapter constitute a complete meal. They are consumed indiscriminately at breakfast, lunch, or dinner. This sublime recipe comes from my mother, a native of Hanoi. She always made the beef stock in large quantities—enough for at least three meals—and froze it in batches until needed. To facilitate the cutting of the beef into paper-thin slices, freeze it for 30 minutes before slicing.

5 pounds beef bones with marrow

5 pounds oxtails

2 pounds short rib plate, or 1 pound flank steak

2 large unpeeled onions, halved, and studded with 8 whole cloves

3 shallots, unpeeled

1 (2-ounce) piece fresh ginger (about a 4-inch piece), unpeeled

8 star anise

1 cinnamon stick

4 medium parsnips, cut into 2-inch chunks

2 teaspoons salt

1 pound beef sirloin

2 scallions, thinly sliced

1 tablespoon shredded coriander

2 medium onions, sliced paper-thin

1/4 cup hot chili sauce

1 pound (1/4-inch wide) dried rice sticks

1/2 cup *nuoc mam* or *nam pla* (Vietnamese or Thai fish sauce)

Freshly ground black pepper

ACCOMPANIMENTS

2 cups fresh bean sprouts

2 fresh Thai or serrano chile peppers, sliced

2 limes, cut into wedges

1 bunch of fresh mint, separated into leaves

1 bunch of Thai basil or regular sweet basil, separated into leaves

The night before, rinse the bones under cold running water and soak overnight at room temperature in a pot with enough water to cover. (This will help loosen the impurities, so when heat is applied, they rise to the top more quickly and can be easily removed, thereby producing a clear broth.)

Place the beef bones, oxtails, and short rib plate in a large stockpot. Add water to cover and bring to a boil. Cook for 10 minutes. Drain. Rinse both the pot and the bones. Return the bones to the pot and add 6 quarts of water. Bring to a boil. Skim the surface to remove the foam and fat and occasionally stir the bones at the bottom of the pot to free additional impurities. Continue skimming until the foam ceases to rise. Add an additional 3 quarts of water and bring back up to a boil. Skim off any more residue, lower the heat, and simmer.

Meanwhile, char the clove-studded onions, shallots, and ginger over a gas burner or under the broiler until they release their fragrances. Tie the charred vegetables, star anise, and cinnamon stick together in a double thickness of dampened cheesecloth. Add the spice bag, parsnips, and salt to the broth and simmer for 1 hour.

Remove the short rib plates from the pot. Pull the meat away from the bones. Reserve the meat and return the bones to the pot. Continue simmering the broth, uncovered, for 4 to 5 hours, keeping a close watch on the liquid level; as it boils away, add enough fresh water to cover the bones.

Meanwhile, slice the beef sirloin against the grain into paper-thin slices, roughly 2 x 2 inches in size. Slice the reserved short rib meat paper-thin. Set aside.

In a small bowl, combine the scallions, coriander, and half of the sliced onions; set aside. Place the remaining sliced onions in a small bowl and stir in the hot chili sauce. Blend well and set aside.

Soak the rice sticks in warm water for 30 minutes. Drain and set aside. When the broth is ready, remove and discard all of the bones. Strain the broth through a strainer or cheesecloth into a clean pot. Add the fish sauce and bring the broth to a boil. Reduce the heat and keep the broth at a bare simmer.

(continued on page 52)

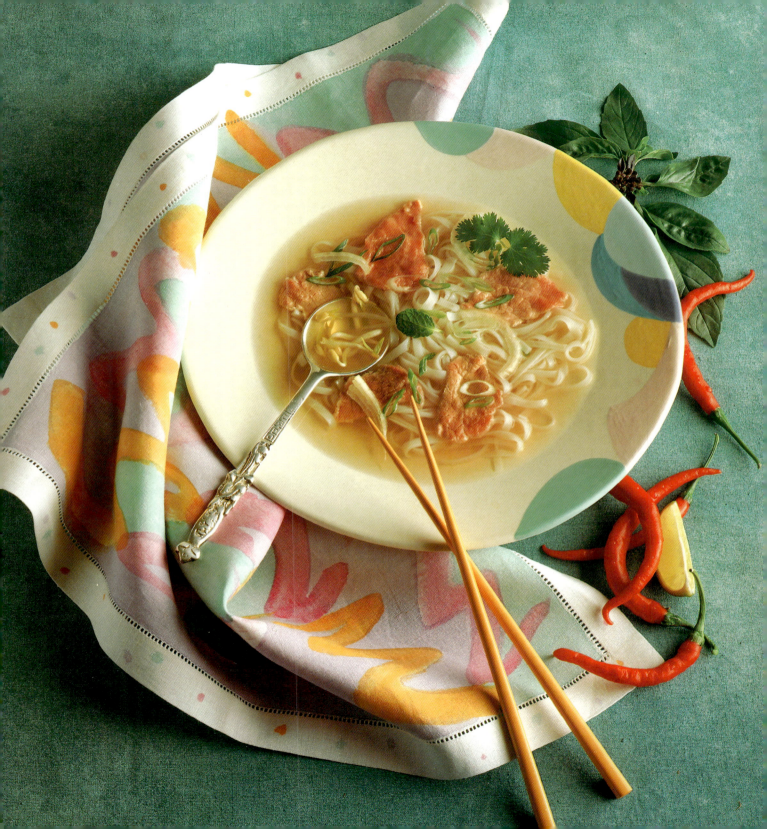

In another pot, bring 4 quarts of water to a boil. Drain the soaking noodles, then drop them into the boiling water. Drain immediately. Divide the noodles among 4 large soup bowls and top them with the sliced meats. Bring the broth back to a rapid boil. Ladle the broth directly over the meat in each bowl (the boiling broth will cook the raw beef instantly). Garnish with the scallion mixture and freshly ground black pepper.

Serve the onion in hot chili sauce and the accompaniments on the side. Each diner will add these ingredients as desired.

Yield: 4 servings

Hue Rice
Com Huong Giang

Fragrantly seasoned, this spicy and tasty rice dish is also simple to make. Like most rice dishes, it may be served for breakfast, lunch, or dinner.

3 cups cooked rice, cold
1 tablespoon dried shrimp
 Nuoc Cham (page 29)
1 stalk fresh lemongrass, outer leaves removed, trimmed and minced
2 shallots, sliced
2 garlic cloves, chopped

2 teaspoons sugar
2 fresh Thai or serrano chile peppers, seeded and chopped
4 tablespoons vegetable oil
2 scallions (both green and white parts), sliced
1 small onion, chopped

2 tablespoons chicken broth or water
2 tablespoons *nuoc mam* or *nam pla* (Vietnamese or Thai fish sauce)
 Freshly ground black pepper
1 tablespoon sesame seeds, toasted and ground
 Coriander sprigs, for garnish

Rub the cold rice with wet hands to separate the grains. Set aside. Soak the dried shrimp in hot water for 30 minutes. Drain.

Prepare the *Nuoc Cham* and set aside.

Grind together the shrimp, lemongrass, shallots, garlic, sugar, and chiles.

Heat 2 tablespoons of the oil in a wok or skillet. Add the scallions and stir-fry for 1 minute. Add the lemongrass and dried shrimp mixture, and stir-fry for 5 minutes over high heat. Transfer to a plate. Pour the remaining 2 tablespoons of oil into the wok. Add the onion and stir-fry until translucent. Add the rice and stir-fry for 5 minutes.

Stir in the broth, fish sauce, and black pepper to taste. Add the lemongrass and shrimp mixture and the toasted sesame seeds. Stir well to combine. Transfer to a heated platter. Sprinkle with additional black pepper and garnish with the coriander sprigs. Serve with *Nuoc Cham.*

Yield: 4 servings

Crispy Rice Pancake
Banh Xeo

Banh Xeo, roughly means "noisy" pancake, and aptly describes this Vietnamese-style crêpe. When poured into the skillet, the batter makes a sizzling sound. The batter can be prepared one day ahead and the accompaniments can be assembled just before serving. The crêpes can be cooked and stuffed a few hours in advance, then reheated as needed. The use of coconut milk in this recipe is typical of southern Vietnamese specialties. This crêpe is traditionally prepared in a wok, but a good omelet pan will also work well. Remember to stir the rice batter well before each addition to the pan.

CRÊPE BATTER
3/4 cup dried yellow mung beans
2 cups fresh or canned coconut milk
I cup rice flour
1/2 teaspoon sugar
1/2 teaspoon salt
1/4 teaspoon turmeric

ACCOMPANIMENTS AND FILLING
Nuoc Cham with Shredded Carrots and
 Daikon (page 29)
 Prepared vegetable platter (page 21)
4 ounces pork butt or shoulder, cut into
 12 thin slices
12 raw medium shrimp, shelled,
 deveined, and halved lengthwise
I 1/2 tablespoons *nuoc mam* or *nam pla*
 (Vietnamese or Thai fish sauce)

4 large garlic cloves, minced
1/4 teaspoon sugar
 Freshly ground black pepper
2 cups thinly sliced fresh mushrooms
 (about 1/2 pound)
2 cups fresh bean sprouts (about 1/2
 to 3/4 pound)
I large onion, thinly sliced
3/4 cup vegetable oil

Prepare the crêpe batter: Cover the mung beans with water and soak for 30 minutes. Drain. Set aside I cup for the filling. Place the remaining 1/2 cup in a blender with the coconut milk and process to a fine purée. Add the rice flour, sugar, salt, and turmeric; blend well. Strain the mixture into a bowl or jar and refrigerate.

Steam the reserved mung beans for about 20 minutes, or until tender. Allow to cool. Cover and set aside.

Prepare the *Nuoc Cham* and assemble the vegetable platter. Set aside.

In a bowl, combine the pork and shrimp with the fish sauce, garlic, sugar, and black pepper to taste. Cover and refrigerate for 30 minutes. In another bowl, combine the mushrooms, bean sprouts, onion, and the cooked mung beans. To facilitate last-minute assembly, divide the mixture into 6 portions on a tray.

Heat 2 tablespoons of the oil in a skillet over high heat. Add the pork and shrimp mixture and stir-fry for 2 minutes, or until the pork loses its pink color and the shrimp turn opaque. Remove to a platter.

In a wok or an 8-inch nonstick omelet pan, heat 2 tablespoons of the oil over medium-high heat. When the oil is very hot, stir the rice batter well and pour 1/2 cup of batter into the wok. Quickly tilt the wok to evenly spread the mixture and form a thin pancake. Scatter I mound of the vegetables, 2 slices of pork, and 4 pieces of shrimp on the lower half of the pancake. Reduce the heat to medium. Cover the pan and cook for about 5 minutes, or until the bottom of the pancake is brown and crispy. Fold the pancake in half and slide it onto a platter. Keep warm in a low oven. Repeat with the remaining oil, batter, and filling, to make 5 more crêpes.

To serve, each diner places a piece of the rice crêpe with some filling on a lettuce leaf with selected herbs from the vegetable platter and strands of carrot and daikon from the dipping sauce. The diner rolls the bundle up, dips it in *Nuoc Cham*, and eats the roll by hand.

Yield: 6 servings

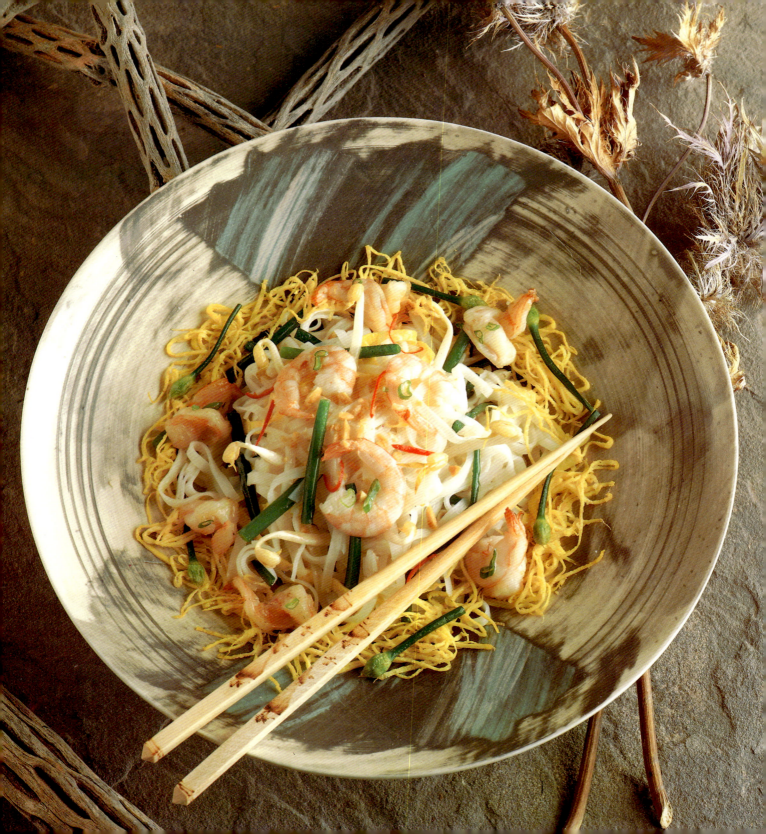

Cool Rice Noodles
with Shrimp & Chinese Chives
Pho Kho Tom

When I was a child, this noodle dish was sold by street vendors in the early morning. I will never forget running out to the street with my own bowl to buy the first meal of the day. The vendor would fill my bowl and my sister's with this hearty noodle dish, which we would consume with gusto before setting off for school. This dish is ideal for hot summer days. If you are fortunate enough to find Chinese chive buds, cut them into 2-inch lengths and blanch them before adding to the noodles.

8 ounces *banh pho* (dried rice sticks)

EGG PANCAKES
2 eggs
1/4 teaspoon *nuoc mam* or *nam pla*
 (Vietnamese or Thai fish sauce)
 Freshly ground black pepper
 Vegetable oil

SOUP
1 fresh Thai or serrano chile pepper,
 seeded and minced
2 tablespoons sugar
1/4 cup rice vinegar or distilled white
 vinegar
1/4 cup plus 2 teaspoons *nuoc mam* or *nam
 pla* (Vietnamese or Thai fish sauce)
3 large garlic cloves, minced

1 pound raw medium shrimp, peeled,
 deveined, and halved lengthwise
 Freshly ground black pepper
3 cups fresh bean sprouts
1 tablespoon peanut oil
2 shallots, thinly sliced
4 scallions, thinly sliced
1/2 cup unsalted pan-toasted or dry-
 roasted peanuts, ground
 Coriander sprigs, for garnish

Prepare the rice sticks: Soak the rice sticks in warm water for 30 minutes. Drain. Bring 4 quarts water to a boil in a large pot. Drop in the noodles. With a pair of chopsticks, lift and separate the noodle strands to prevent clumping. As soon as the water returns to a boil, drain immediately in a colander. Refresh the noodles under cold running water, fluffing them with the chopsticks to remove all excess starch. Drain and set aside.

Prepare the egg pancakes: Beat together the eggs, fish sauce, pepper to taste, and 1/2 teaspoon of water in a bowl.

Brush the bottom of a 9-inch nonstick omelet pan with some oil. Place over medium heat until hot. Pour in 1/4 cup of the egg mixture and immediately tilt the pan to spread it evenly over the bottom. The egg pancake should be very thin and crêpe-like. Cook until egg is set, about 30 seconds. Turn and cook on the other side for 15 seconds longer. Transfer to a plate or cutting board. Repeat with remaining mixture.

When pancakes are cool, roll them into a cylinder and cut crosswise into thin strips.

In a bowl, combine the chile, sugar, vinegar, 1/4 cup of the fish sauce, and half of the garlic. Stir to blend; set aside. In another bowl, combine the shrimp, the remaining 2 teaspoons fish sauce, the remaining garlic, and black pepper to taste. Marinate for 30 minutes.

Blanch the bean sprouts in a pot of boiling water and drain immediately. Refresh the sprouts under cold running water. Drain thoroughly.

Heat the oil in a wok or large skillet over high heat. Add the shallots and stir-fry until lightly browned. Add the shrimp mixture and cook briefly until the shrimp turn pink and curl, about 1 minute. Add the scallions and cook for 1 minute. Remove from the heat.

(continued on page 56)

Place the noodles, bean sprouts, shrimp, half of the egg strips, and ground peanuts in a large bowl. Drizzle the dressing over the mixture; toss well.

Transfer the noodle salad to 4 pasta bowls. Garnish with the coriander and the remaining egg strips.

Yield: 4 servings

Glutinous Rice (Sticky Rice)
Xoi Nep

Because glutinous rice, or "sticky rice" contains no amylose, it blends together into a sticky dough when cooked in water. This is why it is usually steamed. In Vietnam, sticky rice is frequently served at breakfast. It can replace plain rice and may also be served with dipping sauces or simmered dishes, and on special occasions when it is combined with many other ingredients. Sticky rice is the staple food for Buddhists and vegetarians. Instructions for two different cooking methods are given below. In both instances, before beginning the recipe, soak 2 cups of rice in cold water for at least 8 hours or overnight. Rinse and drain.

To prepare by steaming: Spread the soaked rice over a dampened cheesecloth in the top of a steamer and steam for 20 to 30 minutes, sprinkling the rice with water. Sample the rice as it cooks and monitor its tenderness as you would with pasta.

To prepare by boiling: In a heavy-bottomed saucepan, bring 3 cups of water to a boil over high heat. Add the rice and bring back up to a boil. Continue boiling for 1 minute, then cover the saucepan with a tight lid and remove it from the heat. Hold the cover securely on the saucepan and drain off all of the water.

Return the saucepan to a very low heat (if using an electric stove, have a second burner preheated at the lowest setting), and cook, covered, for 20 minutes. Set aside for 10 minutes before serving. Remove the saucepan lid and fluff with a fork or chopsticks.

NOTE: Do not discard the crust on the bottom of the pan. Dip it in sauces, or deep-fry and eat it as a cracker.

Yield: 4 cups cooked rice

Golden Noodle Soup with Chicken & Eggplant
Mi Ga Nau Ca Tim

This fragrant noodle soup is one of southern Vietnam's most glorious dishes, consumed with gusto, everywhere from restaurants to roadside stands.
To achieve optimum flavor, you must use Vietnamese wet curry paste.

BROTH
2 teaspoons vegetable oil
1 tablespoon Vietnamese curry paste
 packed in oil
2 teaspoons curry powder
1 cup chopped onions
2 (4-inch) pieces fresh lemongrass,
 crushed
4 large Kaffir lime leaves

3 1/2 cups chicken broth
3 1/2 cups unsweetened coconut milk
1/4 cup *nuoc mam* or *nam pla* (Vietnamese
 or Thai fish sauce)

NOODLES AND CHICKEN
1/2 pound fresh spinach, stemmed,
 washed, and dried, or 1 package
 (10-ounces) frozen leaf spinach, thawed

1/2 pound flat egg noodles
4 Japanese eggplants, halved lengthwise
 and cut into 1/2-inch-thick slices
1 pound boneless, skinless chicken thigh
 or breast, cut into 1/2-inch strips
 Fresh coriander sprigs, for garnish
4 lemon wedges

Heat the oil in a large saucepan over medium heat. Stir in the curry paste and curry powder, and cook for 30 seconds. Add the onions, lemongrass, and lime leaves, and sauté until the mixture is fragrant and the onions are tender, about 2 minutes.

Stir in the chicken broth and coconut milk and bring to a boil, then lower the heat and simmer until aromatic, about 10 minutes. Stir in the fish sauce, then remove the broth from the heat and set aside. (This broth can be prepared several hours ahead of time.)

If using fresh spinach, cook leaves in a large pot of rapidly boiling, salted water (at least 3 quarts) until tender, about 1 minute. Transfer the spinach to a colander with tongs or a slotted spoon, rinse with cold water, and drain. Cook, rinse, and drain the noodles in the same way as the spinach. Divide the noodles and spinach among 4 large soup bowls.

Bring the broth to a simmer over medium-low heat. Add the eggplants and cook until tender, about 5 minutes. Add the chicken and simmer until just tender, about 2 minutes.

To serve, ladle the curry broth over the noodles and garnish each bowl with a sprig of coriander and a lemon wedge. Serve immediately.

Yield: 4 servings

Warm Rice Noodles with Stir-Fried Beef, Saigon Style

Bun Bo

This southern single-dish meal is a favorite of mine; it is also the one dish that I like to introduce to friends experiencing Vietnamese food for the very first time. After this initiation, they are usually eager to try other dishes. There is no easier or better way to entertain in the summer than with this delicious, warm pasta salad; except for the sautéed beef, which should be hot, everything else is prepared ahead of time and assembled in individual bowls. The final step is a rapid stir-fry of the meat, which then tops the noodle-salad mixture.

I pound *bun* (thin rice vermicelli) or 4 bundles *somen* (Japanese alimentary paste noodles), prepared according to directions on page 60
Nuoc Cham with Carrot and Daikon (page 29), double the recipe amount
3 stalks fresh lemongrass
I 1/2 pounds lean beef chuck or top round

2 tablespoons *nuoc mam* or *nam pla* (Vietnamese or Thai fish sauce)
6 garlic cloves, chopped
3 teaspoons curry powder
Freshly ground black pepper
8 leaves of soft lettuce, thinly shredded
1/2 cup thinly shredded mint leaves
I small cucumber, peeled, seeded, and finely shredded

I cup fresh bean sprouts
3 tablespoons peanut oil
2 small onions, thinly sliced
2/3 cup unsalted pan-toasted or dry-roasted peanuts, ground
Coriander leaves, for garnish

Prepare the noodles and the *Nuoc Cham* with Carrot and Daikon; set aside.

Peel and discard the outer leaves of the lemongrass, and with a sharp knife, cut and discard the upper half of the stalks at the point where the leaves branch out. Thinly slice the trimmed stalks.

Cut the beef against the grain into thin 2 x 2-inch slices. In a bowl, combine the beef with the fish sauce, half of the garlic, I teaspoon of the curry powder, and black pepper to taste. Marinate for 30 minutes.

In a large bowl, combine the shredded lettuce, mint, cucumber, and bean sprouts and toss well. Divide the mixed vegetables evenly among 4 pasta bowls. Top the vegetables with the cooked, drained noodles; cover and refrigerate until ready to serve.

Heat the oil in a wok or large skillet. Add the remaining garlic and stir-fry until fragrant. Add the onions, lemongrass, and the remaining 2 teaspoons curry powder; stir-fry until the onions are translucent, about 2 minutes. Add the beef to the wok and stir-fry over high heat until the beef is browned, about I minute. Divide the beef evenly among the 4 bowls of noodles. Top each bowl with the ground peanuts and garnish with coriander leaves.

Pass the *Nuoc Cham* at the table. Before eating, diners should season their bowl of noodles with a generous amount of the sauce and toss well.

Yield: 4 servings

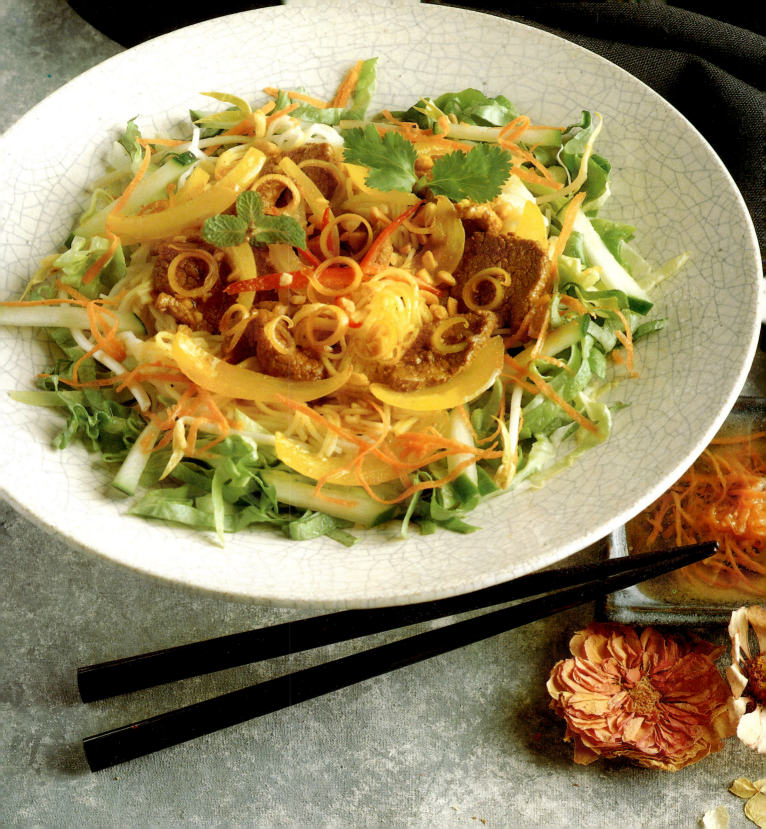

Noodles with Stir-Fried Fish, Hanoi Style
Cha Ca

*Cha Ca, the Vietnamese term for "fried fish," also refers to an indigenous variety of freshwater fish. At the famous
Cha Ca Restaurant in Hanoi, where this dish is the specialty of the house, the fish arrives at the table fileted and marinated. As it is cooked on a
charcoal brazier, a handful of fresh dill is tossed in. The fish is served with rice noodles, lots of fresh herbs, and roasted peanuts.
I cook and assemble everything in the kitchen and let my guests enjoy their food.*

Nuoc Cham (page 29), double the recipe amount

1/$_2$ pound *bun* (thin rice vermicelli) or 2 bundles somen (Japanese alimentary paste noodles)

1 1/$_2$ pounds cleaned monkfish or swordfish filet

1 1/$_2$ tablespoons *nuoc mam* or *nam pla* (Vietnamese or Thai fish sauce)

1 1/$_2$ teaspoons turmeric powder

3 tablespoons finely chopped galangal, or 2 teaspoons finely grated fresh, peeled ginger (about a 3/$_4$-inch piece)

2 tablespoons chopped shallots (about 2 large shallots)

2 teaspoons chopped garlic (about 4 medium cloves)

1/$_2$ teaspoon gound white pepper

1 tablespoon plus 2 teaspoons peanut oil

3/$_4$ cup sliced scallions, green parts only

1 1/$_2$ cups firmly packed fresh dill, coarsely chopped

3/$_4$ cup firmly packed fresh Thai basil or regular sweet basil leaves, coarsely chopped

3/$_4$ cup coarsely chopped coriander leaves

1/$_2$ cup unsalted pan-toasted or dry-roasted peanuts, coarsely chopped

Prepare the *Nuoc Cham*. Set aside.

Prepare the noodles: For the rice vermicelli, soak in warm water for 15 to 20 minutes. Drain. Bring 4 quarts of water to a boil in a large pot. Drop in the noodles. With a pair of chopsticks, lift and separate the strands to prevent clumping. Boil the noodles for no longer than 2 to 3 minutes. Test after 2 minutes for an *al dente* consistency. Drain the noodles and rinse well under cold water to remove excess starch. Drain well.

For the alimentary paste noodles, cook the two bundles in 4 quarts of boiling salted water for no longer than 1 or 2 minutes. With a pair of chopsticks, lift and separate the strands to prevent clumping and test after 1 minute for an *al dente* consistency. Drain and rinse as in vermicelli preparation.

Rinse the fish under cold running water and pat dry with paper towels. Cut the fish into 1/$_2$-inch-thick slices.

In a mixing bowl, combine the fish with the fish sauce, turmeric, galangal, shallots, garlic, white pepper, and 1 tablespoon of the peanut oil. Stir until well blended, then cover and let marinate in the refrigerator for 30 minutes.

Heat a wok or large skillet over high heat, add the remaining 2 teaspoons peanut oil, and heat until smoking-hot. Add the marinated fish and stir-fry until golden on the outside and just cooked through, about 2 to 3 minutes. Remove the skillet from the heat, then stir in the scallions and half of the dill.

Divide the noodles among shallow pasta bowls and top them with the fish. Sprinkle with the peanuts and remaining herbs. Drizzle with a generous amount of *Nuoc Cham* and serve immediately.

Yield: 4 servings

FISH & SEAFOOD

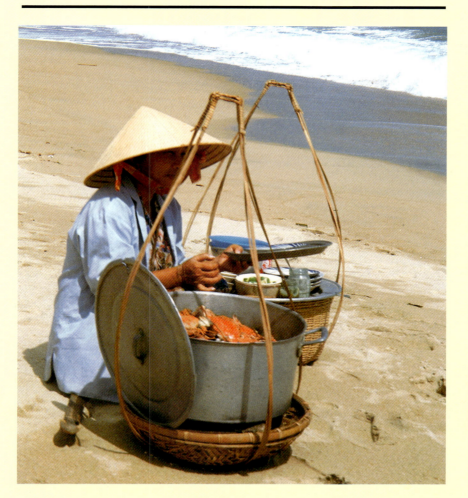

Boneless Stuffed Whole Fish
Ca Rut Xuong Don Thit

Stuffed whole fish is a prized dish frequently offered at Vietnamese banquets. The fish head itself is considered a delicacy, and it is commonly believed that eating it will bring good luck. The fish may be grilled over a charcoal fire; just remember to baste it frequently with oil to keep it from drying out.

PICKLED CARROTS
1/2 cup rice vinegar
I tablespoon sugar
1/4 teaspoon salt
3 carrots, peeled and cut crosswise into
 1/8-inch rounds

FISH
 Nuoc Cham (page 29)
1/2 tablespoon dried tree ear mushrooms

1/2 ounce cellophane (bean thread)
 noodles
4 shallots, minced
4 garlic cloves, minced
1/4 teaspoon salt
1/4 teaspoon sugar
I tablespoon *nuoc mam* or *nam pla*
 (Vietnamese or Thai fish sauce)
Freshly ground black pepper
I (2 1/2-pound to 3-pound) red snapper,

sea bass, or carp, boned and cleaned,
 with head and tail left intact
4 ounces ground pork
2 ounces fresh lump crabmeat,
 thoroughly picked over
1/2 medium onion, minced
I egg, lightly beaten
Vegetable oil
Lemon and lime wedges, for garnish
Coriander sprigs, for garnish

Prepare the pickled carrots: Combine the vinegar, sugar, salt, and 1/2 cup of water in a small saucepan. Bring to a boil. Remove and let cool to room temperature. Add the carrot rounds to the mixture and marinate for at least 1 hour. Drain the carrots and set aside.

Prepare the *Nuoc Cham* and set aside.

Preheat the oven to 400°F.

Soak the mushrooms in hot water and the cellophane noodles in warm water for 30 minutes. Drain. Mince the mushrooms and cut the cellophane noodles into 1-inch lengths.

In a medium bowl, mix together the shallots, garlic, salt, sugar, fish sauce, and black pepper to taste. Rub the inside of the fish with half of the seasoning. Combine the remaining half with the pork, crabmeat, onion, egg, noodles, and mushrooms. Mix well. Fill the fish cavity with the stuffing and tie the opening closed with string.

Line a baking pan with a double thickness of aluminum foil, leaving an excess length at both ends so the fish can be removed by lifting the foil. Generously oil the pan. Place the fish in the pan and brush with oil.

Bake, uncovered, until the fish flakes easily when tested with a fork and the pork is cooked through, about 30 to 35 minutes.

To serve, transfer the fish to a large platter. Arrange the pickled carrots, lemon and lime wedges, and coriander sprigs around the fish. Pass the *Nuoc Cham* separately.

Yield: 4 to 6 servings

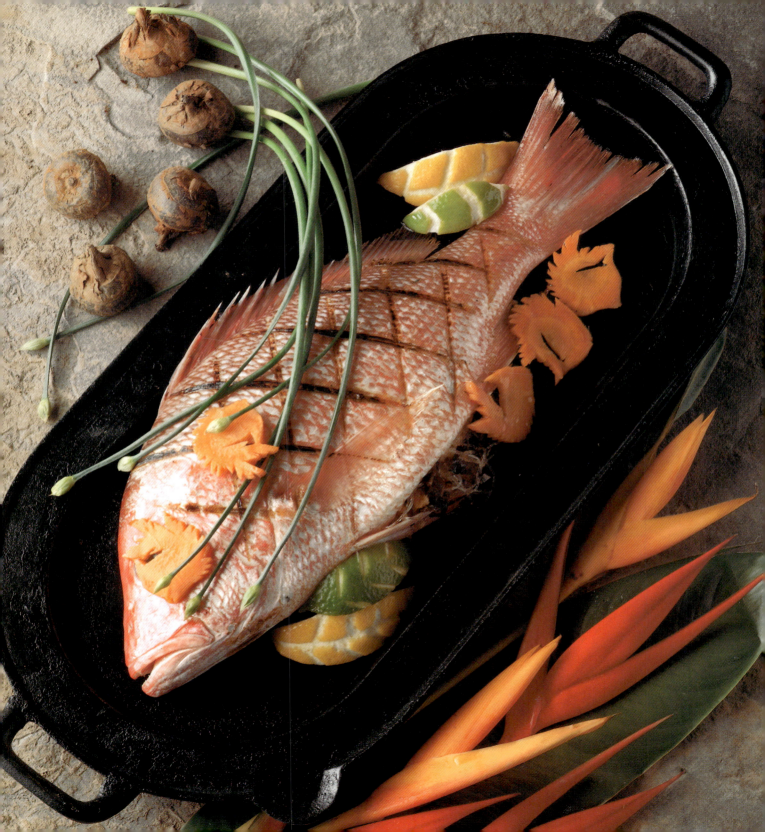

Catfish in Black Pepper Sauce
Ca Tre Kho Tieu

This homespun fish entrée is simmered slowly in a sweet and salty black pepper sauce, allowing the flavors to mingle and the fish to emerge moist and buttery. I enjoy serving it with a bowl of steamed jasmine rice and a cool vegetable side dish, such as Tangy Bean Curd and Watercress, to balance the spiciness of the sauce. The best part of the meal is spooning the succulent sauce over the rice.

3 tablespoons sugar
1/4 cup hot water
1 tablespoon *nuoc mam* or *nam pla* (Vietnamese or Thai fish sauce)

1 tablespoon soy sauce
2 large cloves garlic, finely chopped
1 teaspoon freshly ground black pepper
1/2 medium onion, thinly sliced

1 pound catfish filet, cut crosswise into thirds

Prepare the pepper sauce: Place the sugar in a nonstick omelet pan and cook over medium-high heat (without stirring) until the sugar has melted and begins to change color, about 3 minutes. Continue to cook, swirling the liquid in the pan until it turns a rich golden brown and starts to bubble and smoke slightly, about 30 seconds longer. Quickly remove the pan from the heat and add the hot water, being extremely careful since the mixture will boil vigorously. Wait a minute or two for it to settle, then add the fish sauce and soy sauce. Return to a low heat and simmer for about 2 minutes, then quickly remove once more from the heat and stir in the garlic and black pepper. Let cool slightly.

Arrange the sliced onion in the bottom of a heavy saucepan large enough to hold the fish in one layer. Place the fish filets on top and drizzle with the pepper sauce. Cover and refrigerate for at least 30 minutes, or up to 2 hours. Bring the saucepan to room temperature before cooking.

To cook, place the saucepan over medium-high heat and bring the sauce to a boil. Quickly reduce the heat to low, cover, and simmer until the fish flakes easily when pierced with a fork, about 10 to 15 minutes. Serve immediately.

Yield: 4 servings

Red Snapper in Minted Tamarind Sauce
Ca Chien Sot Me Chua

*Anyone who has sampled this agrees that it is one of the best fish dishes they've ever eaten.
The exquisite combination of sweet, sour, and spicy flavors in the sauce—enhanced with cool mint—makes for an outstanding
taste sensation. The sauce is also excellent with grilled chicken or almost any steamed or grilled seafood.*

2 tablespoons tamarind pulp
2/3 cup boiling water
3 tablespoons *nuoc mam* or *nam pla*
 (Vietnamese or Thai fish sauce)
1 tablespoon light soy sauce
2 1/2 tablespoons sugar
4 (6-ounce) red snapper filets

Freshly ground black pepper
1 cup all-purpose flour, for dredging
1 tablespoon plus 2 teaspoons peanut
 oil
4 peeled fresh ginger slices (each
 about the size of a quarter), thinly
 shredded (about 1 heaping tablespoon)

1 tablespoon minced garlic (about 5 to
 6 cloves)
3 fresh Thai or serrano chile peppers,
 finely chopped
2 tablespoons finely shredded fresh
 mint leaves
Fresh mint sprigs, for garnish

Place the tamarind in a small bowl, pour in the boiling water, and let soak, covered, for 15 minutes. When the tamarind has become quite soft, mash it thoroughly with the tips of your fingers to release as much pulp as possible. Strain through a fine sieve into a bowl, pressing on the seeds and fibers to extract as much pulp as possible. Discard the seeds and fibers. There should be about 1/2 cup tamarind liquid.

Add the fish sauce, soy sauce, and sugar to the tamarind liquid. Gently stir until the sugar is dissolved; set aside.

Pat the filets dry and season them with pepper. Dredge each filet in the flour, shaking off any excess. Arrange the filets on a platter.

Heat a large nonstick skillet over high heat for 10 seconds, then add the 1 tablespoon of peanut oil. When the oil is smoking-hot, carefully add the filets, skin side down. Reduce the heat to medium-high, cover the skillet, and cook until the skin side is crisp and golden brown, about 5 minutes. Using a wide metal spatula, carefully turn the filets. Continue to cook, uncovered, for 1 minute longer.

Transfer the filets to a large platter. Loosely cover the fish with foil and set aside.

Wipe the skillet clean and return it to a medium-high heat for 30 seconds. Add the remaining 2 teaspoons of oil, then the ginger, garlic, and chile peppers. Stir-fry until aromatic, about 30 seconds. Quickly stir the tamarind mixture and add it to the skillet. Cook until the sauce thickens slightly, about 1 minute. Do not overcook or it will become too salty.

Remove the skillet from the heat and stir in the mint leaves. Spoon the sauce over the filets and garnish with fresh mint sprigs. Serve immediately.

Yield: 4 servings

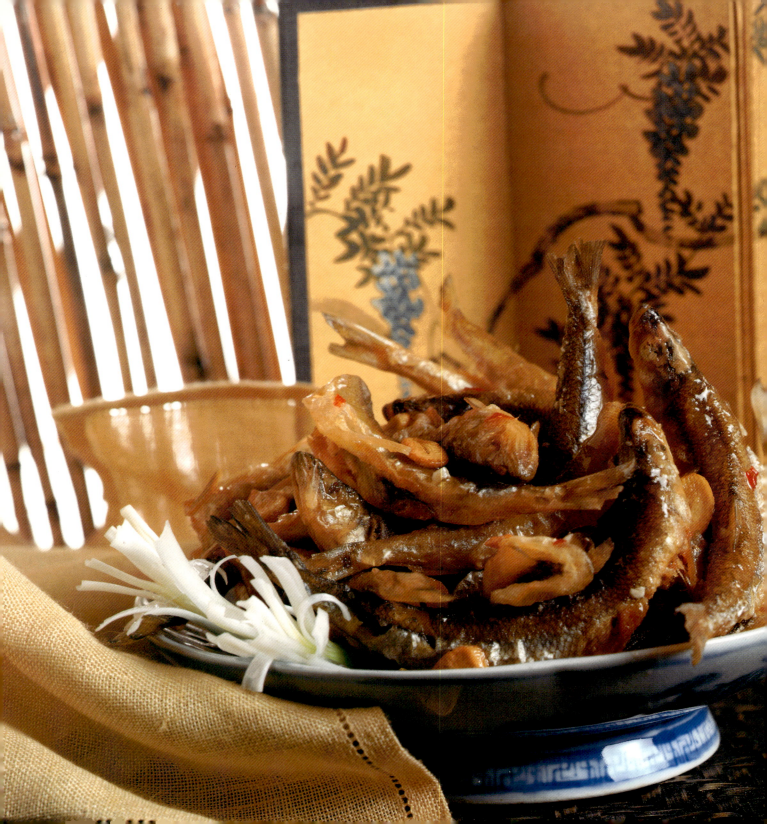

Saigon Fish
Ca Chien

Next to pork and poultry, fish is the most important food in the Vietnamese diet. This is due, no doubt, to the bountiful harvest of the sea and rivers, which are so much a part of the landscape. This superb dish of crisply fried smelts in a light piquant sauce is very popular in the south. If fresh smelts are unavailable, the recipe adapts well to other types of firm-fleshed fish such as red snapper, whiting, or sea bass.

2 tablespoons sugar
2 teaspoons plus 1 tablespoon finely chopped garlic (about 10 to 12 medium cloves)
2 fresh Thai or serrano chile peppers
1/3 cup hot water

3 tablespoons rice vinegar
1/4 cup *nuoc mam* or *nam pla* (Vietnamese or Thai fish sauce)
1 1/2 tablespoons fresh lime juice
2 tablespoons peanut oil
2 pounds fresh smelts, cleaned, with heads removed

All-purpose flour, for coating
Vegetable oil, for deep-frying
2 teaspoons rice flour, mixed with 4 teaspoons cold water
Fresh coriander sprigs, for garnish
Lime wedges, for garnish

Prepare the sauce: Combine the sugar, 2 teaspoons of garlic, and the chile peppers in a mortar and pound to a fine paste. Transfer the paste to a small bowl and stir in the hot water, vinegar, fish sauce, and lime juice. Cover and set aside.

Prepare the garlic oil: Place the peanut oil and the remaining tablespoon of chopped garlic in a small saucepan over medium-low heat and slowly cook until crisp and golden brown, about 3 to 5 minutes. Do not overcook or the garlic will acquire a bitter taste. Remove the pan from the heat and set aside to cool.

Rinse the smelts and pat them dry with paper towels. Roll the smelts, a few at a time, in the flour. Shake off any excess flour and arrange them in a single layer on a baking sheet.

Line another baking sheet with a double layer of paper towels. Set aside. In a deep-fryer, add oil to a depth of 3 inches and heat to 350°F, or until a piece of scallion sizzles and browns instantly when added. Fry the smelts in batches until golden brown on both sides, about 3 minutes. Use a slotted spoon to transfer the smelts onto the prepared baking sheet.

Turn the heat to high and heat the oil to 365°F. Return the smelts to the deep-fryer and fry once more until crisp, about 1 minute. Drain on paper towels, then transfer to a serving platter.

In a medium skillet, mix together the sauce and the dissolved rice flour. Heat over low heat, swirling the sauce frequently, until it is slightly thickened, about 1 minute. Remove the skillet from the heat and stir in the garlic oil. Quickly drizzle the sauce over the smelts. Garnish with coriander sprigs and lime wedges and serve immediately.

Yield: 4 to 6 side-dish servings

POULTRY

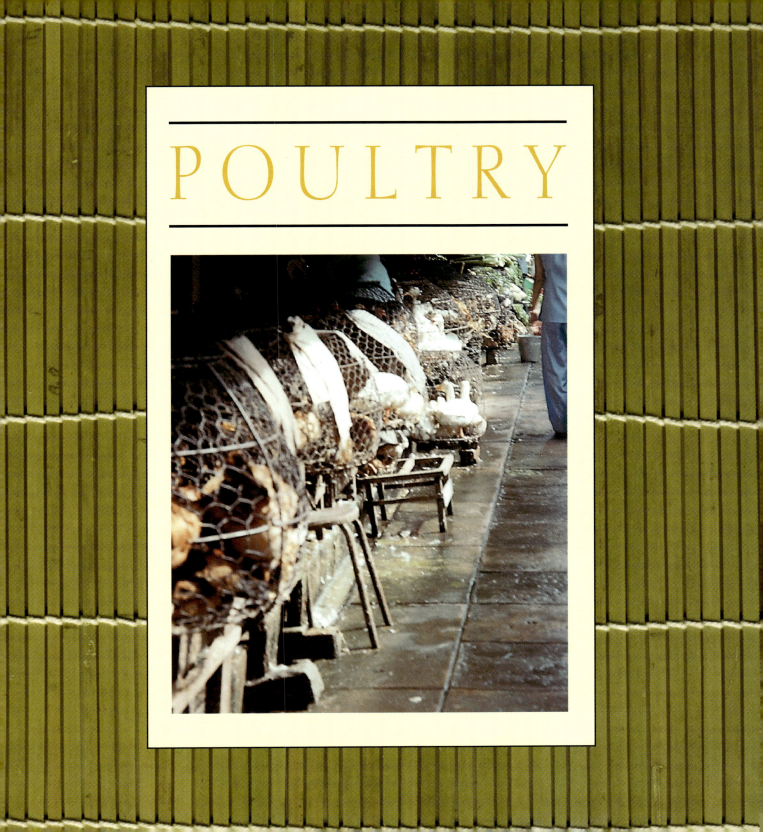

Stir-Fried Chicken with Lemongrass & Caramelized Onions
Ga Xao Xa

When you cook this superb dish, the wonderful fragrance of sweet onions and lemongrass will permeate your kitchen. The key to this recipe is to sear the chicken in a hot skillet to retain its moisture and tenderness. To ensure a rich flavor and appearance, be sure to let the onions fry gently until they develop a golden color and pronounced sugary taste.

MARINADE
2 stalks fresh lemongrass
4 fresh Thai or serrano chile peppers, coarsely chopped
2 teaspoons minced garlic, (about 4 medium cloves)
2 tablespoons *nuoc mam* or *nam pla* (Vietnamese or Thai fish sauce)

2 tablespoons vegetable oil
1 tablespoon sugar
2 teaspoons cornstarch
1/2 teaspoon freshly ground black pepper
1 pound chicken breast, trimmed of fat

STIR-FRY
4 tablespoons peanut oil
2 medium onions, thinly sliced
1/2 red bell pepper, thinly sliced
1 tablespoon *nuoc mam* or *nam pla*
1/4 cup chicken broth
Fresh coriander sprigs, for garnish
Freshly ground black pepper

Peel and discard the outer leaves of the lemongrass. With a sharp knife, cut off and discard the upper half of the stalks at the point where the leaves branch out. Thinly slice the remaining stalks.

In a food processor, finely chop and blend together the lemongrass, chiles, and garlic. Transfer the mixture to a mixing bowl and stir in the fish sauce, vegetable oil, sugar, cornstarch, and black pepper.

Cut each chicken breast lengthwise in half, then across the grain into 1/4-inch-thick slices. Coat the chicken with the marinade and let it stand for 30 minutes at room temperature.

Heat a large skillet over medium-high heat and add 2 tablespoons of the peanut oil. When the oil is hot, stir-fry the onions until they are golden brown, about 5 minutes. Transfer the onions to a plate. Turn up the heat to high and add the remaining 2 tablespoons of oil. When the oil is very hot, add the chicken and stir quickly to coat with the oil, about 1 minute.

Add the pepper slices, fish sauce, and broth. Stir-fry the mixture until the chicken turns opaque, about 2 minutes longer. Do not overcook. Add the cooked onions and toss to combine with the chicken. Remove the skillet from the heat.

Transfer the mixture to a warmed platter. Garnish with coriander sprigs and top with freshly ground black pepper to taste. Accompany the dish with steamed rice.

Yield: 4 servings

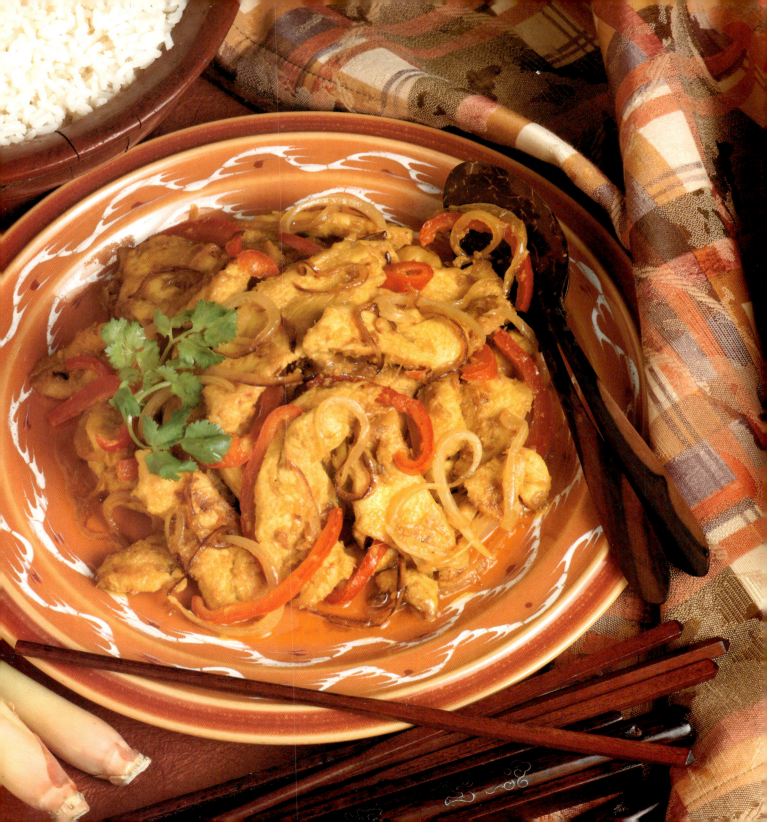

Chicken with Curry & Coconut Sauce
Ca-ri Ga Voi Mien

A quick stir-fry dish, this tasty chicken curry is intensely flavored with coconut milk, lemongrass, and ginger.
Clear cellophane noodles add a unique visual touch.

MARINADE AND CHICKEN
2 stalks fresh lemongrass
2 fresh Thai or serrano chile peppers
 coarsely chopped
1 tablespoon coarsely chopped garlic
 (about 6 medium cloves)
1 pound boneless, skinless chicken
 thighs, trimmed of fat and cut into
 1-inch cubes
1 tablespoon *nuoc mam* or *nam pla*
 (Vietnamese or Thai fish sauce)
2 teaspoons curry powder
1 teaspoon finely grated, fresh peeled
 ginger, (about $1/3$-inch piece)

$1/2$ teaspoon sugar
$1/4$ teaspoon freshly ground black pepper
1 teaspoon peanut oil
1 teaspoon curry paste

STIR-FRY
1 tablespoon peanut oil
1 cup coarsely chopped onions (about 2
 medium onions)
1 cup chicken broth
$1/3$ cup fresh or canned unsweetened
 coconut milk
1 tablespoon *nuoc mam* or *nam pla*
1 $1/2$ teaspoons sugar

2 ounces dried cellophane noodles
 (bean threads), soaked in warm water
 for 20 minutes, drained, and cut into
 2-inch lengths
$1/3$ cup dried tiny tree ear mushrooms,
 soaked in hot water for 20 minutes,
 then drained
2 scallions (both green and white parts),
 trimmed and thinly sliced

Peel and discard the outer leaves of the lemongrass. With a sharp knife, cut off and discard the upper half of the stalks at the point where the leaves branch out. Thinly slice the remaining stalks.

Process the lemongrass, chile peppers, and garlic in a food processor until finely ground.

Transfer the mixture to a mixing bowl. Add the chicken and the remaining marinade ingredients, mixing together until thoroughly blended. Cover and refrigerate for 30 minutes.

When ready to stir-fry, heat a wok or large skillet over high heat. Add the 1 tablespoon of peanut oil and heat until smoking-hot. Add the onions and stir-fry until golden brown, about 2 minutes.

Add the marinated chicken and stir-fry until the chicken is golden on the outside and just cooked through on the inside, about 5 minutes.

Add the broth, coconut milk, fish sauce, and sugar and bring to a boil. Stir in the cellophane noodles and mushrooms. Continue to cook for a minute longer, then remove from the heat and stir in the scallions.

Transfer the stir-fry to a warm platter and serve immediately.

Yield: 4 servings

Ginger-Flavored Roast Duck
Vit Nuong Gung

Delicious with sticky rice or steamed jasmine rice, roast duck is one of the most widely appreciated foods in Vietnam. The bird is usually split in half and rubbed with spices before grilling. Here, the duck halves are marinated in a ginger-flavored sauce overnight to intensify the flavors. In adapting this recipe for the broiler, I've found that adding a little water to the pan prevents the duck fat from smoking and at the same time provides some moisture—resulting in a duck with a crisp skin and tender meat. For an authentic experience, keep the duck meat on the bone when serving and savor eating the pieces with your fingers.

MARINADE
1/4 cup honey
2 tablespoons *nuoc mam* or *nam pla* (Vietnamese or Thai fish sauce)
2 teaspoons soy sauce
2 tablespoons finely grated fresh ginger (about a 2-inch piece)
1 tablespoon finely chopped garlic (about 5 to 6 cloves)

1/2 teaspoon freshly ground black pepper
1 young duckling (about 5 pounds)

GINGER DIPPING SAUCE
2 garlic cloves, crushed
1 1/2 tablespoons sugar
1 fresh Thai or serrano chile pepper, seeded and minced

1 tablespoon grated fresh ginger (about a 1-inch piece)
3 tablespoons fresh lime or lemon juice
3 1/2 tablespoons *nuoc mam* or *nam pla*

Fresh coriander sprigs, for garnish

Prepare the marinade: Combine the honey, fish sauce, soy sauce, ginger, garlic, and black pepper with 1/2 cup water in a small saucepan. Simmer gently for 2 minutes, or until the honey is dissolved. Remove from the heat and set aside.

Remove the neck and giblets from the duck. Remove and discard any excess fat and skin around the neck and cavity. Cut off the wing tips and reserve with the neck and giblets for stock or soup. Place the duck, breast side down, on a cutting board. With poultry shears, open the duck by cutting along the neck through each side of the backbone (save the backbone for soup stock). Spread the duck open, then split it in half lengthwise. Rinse the duck halves and pat them dry with paper towels.

Place the duck halves, breast side up, in a shallow roasting pan, and cover evenly with the marinade. Cover and marinate in the refrigerator for 6 to 8 hours, or overnight, turning the duck occasionally to coat with the marinade.

Preheat the oven to 450°F. Set the rack on the middle shelf.

Prepare the dipping sauce: Combine the garlic, sugar, chile, and ginger in a small bowl or mortar. Crush the mixture to a paste. Add the lime juice and fish sauce and stir to blend. Set aside.

Remove the duck from the marinade (discard the marinade) and blot the skin dry. Place a rack inside of a roasting pan. Place the duck on the rack, breast side up. Using a fork, prick the skin thoroughly, taking care not to pierce through the breast meat. Pour about 1/2 cup of hot water into the bottom of the pan.

Roast the duck for 30 minutes, then reduce the temperature to 350°F. Prick the duck skin again and continue roasting until golden brown, about 30 minutes longer, or until an instant-read thermometer inserted into the thickest part of a thigh registers 165°F. Remove the pan from the oven and preheat the broiler.

Broil the duck halves, rib cage up, until deep brown in color, about 2 minutes. Turn the duck over and continue broiling until the skin is crispy, about 2 to 3 minutes longer.

Transfer the duck to a cutting board. Remove the rib cage, if desired, and using a heavy cleaver or chef's knife, chop the duck into bite-size pieces. To serve, arrange the duck on a warm platter and garnish with fresh coriander sprigs. Serve immediately, accompanied by the ginger dipping sauce.

Yield: 2 main-dish or 4 side-dish servings

Five-Spice Quail
Chim Quay

In Vietnam, game birds such as squab, pigeon, or quail are prized foods and reserved for family celebrations and banquets. In this recipe, I prefer the more delicate quail to the traditional squab. Five-Spice Quail is marinated, steamed, and then deep-fried, resulting in an extremely crispy quail—so crispy you can eat it bones and all—with a moist and tender flesh. This cooking technique can be applied to Cornish game hens, duck legs, or chicken legs. Serve this quail with a salt-and-pepper mixture or Nuoc Cham for dipping, along with cold beer.

2 ounces rock sugar, or 2 tablespoons
 granulated sugar
2 tablespoons freshly grated ginger
(about a 2-inch piece)
4 shallots, minced

4 garlic cloves, minced
1/4 cup light soy sauce
2 tablespoons rice wine or dry sherry
 (optional)
1 teaspoon five-spice powder

1/2 teaspoon freshly ground pepper
8 quail, or 4 small squab
 Vegetable oil, for deep-frying
 Watercress, for garnish

In a mortar, pound or crush the rock sugar, ginger, shallots, and garlic to a fine paste. In a small non-reactive saucepan, mix the paste with the soy sauce, rice wine, five-spice powder, black pepper, and 1/2 cup of water. Stir to combine. Bring the liquid to a boil and stir until the sugar dissolves. Allow to cool slightly. Add the quail and turn to coat evenly. Marinate, turning occasionally, for at least 2 hours or overnight.

Remove the quail from the marinade and drain. Pour a 1-inch layer of water into a wok or wide pot. Place a steamer rack or bamboo steamer over the water. Arrange the quail in a single layer on the rack. Cover and steam for 15 minutes. Remove the quail and allow to cool thoroughly. Pat the quail dry with paper towels. Using poultry shears, cut in half lengthwise.

In a clean wok or deep-fryer, add oil to a depth of 3 inches and heat to 365°F (or until bubbles form around a dry wooden chopstick when inserted). This temperature must be maintained for the entire frying process. Add the quail a few pieces at a time and turning only once, fry until golden brown, about 2 minutes (longer if cooking squab or pigeon). Drain on paper towels and serve immediately on a platter lined with watercress.

NOTE: If using squab or pigeon, cut each half into smaller pieces so diners can eat with their fingers.

Yield: 4 servings

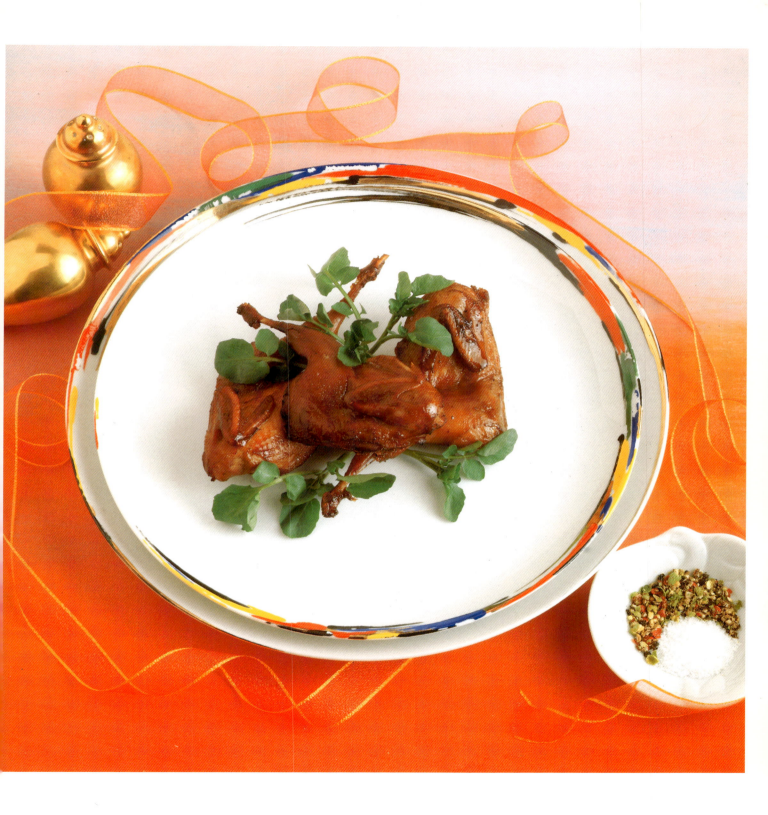

Stir-Fried Chicken with Honey & Ginger
Ga Xao Gung

This toothsome and aromatic dish is fast and easy to put together. You can also try it with duck, pork, or fresh shelled or unshelled prawns. Serve with rice, a vegetable dish, and a soup for a very satisfying meal.

2 tablespoons vegetable oil
1 large onion, cut into wedges
1 pound boned chicken thighs, cut into
 2-inch pieces
6 large garlic cloves, thinly sliced

1 tablespoon thinly shredded ginger
 (about a 1-inch piece)
2 tablespoons honey
2 tablespoons *nuoc mam* or *nam pla*
 (Vietnamese or Thai fish sauce)

2 tablespoons soy sauce
1/2 teaspoon five-spice powder
 Freshly ground black pepper
 Coriander sprigs, for garnish

In a wok or skillet, heat the oil over high heat. Add the onion and stir-fry until lightly browned. Add the chicken and stir-fry until browned, about 3 minutes. Add the garlic and ginger and stir-fry until fragrant. Stir in the honey, fish sauce, soy sauce, and five-spice powder. Toss to combine the ingredients and cook until the chicken pieces are nicely glazed with the sauce, about 3 minutes. Transfer to a hot platter.

Sprinkle with black pepper, garnish with coriander sprigs, and serve with an accompaniment of rice.

Yield: 4 servings

Lime Chicken Brochettes
Ga Nuong Chanh

This recipe calls for marinating the chicken for at least one hour so that the meat absorbs the citrus flavor of the sauce; the longer it marinates, the more succulent and moist the meat will become. Although these chicken brochettes taste best when cooked slowly over a charcoal grill, broiling will also give satisfying results. Be sure not to overcook them!

2 shallots, thinly sliced

2 teaspoons minced garlic (about 4 medium cloves)

4 fresh Thai or serrano chile peppers, coarsely chopped

1 tablespoon sugar

2 tablespoons fresh lime juice

Finely grated zest of 3 limes (a heaping ¹/₂ teaspoon)

1 tablespoon *nuoc mam* or *nam pla* (Vietnamese or Thai fish sauce)

1 tablespoon soy sauce

1 tablespoon peanut oil

¹/₄ teaspoon ground black pepper

1 ¹/₂ pounds boneless, skinless chicken breast, trimmed and cut into 1-inch cubes

1 large onion, peeled and cut into 1-inch squares

8 bamboo skewers, soaked in hot water for 30 minutes

Place the shallots, garlic, chile peppers, and sugar in a mortar or spice grinder and pound or grind to a fine paste. Transfer the paste to a large mixing bowl and stir in the lime juice, lime zest, fish sauce, soy sauce, oil, and black pepper.

Add the chicken pieces and toss well to coat. Cover with plastic wrap and refrigerate for 1 to 2 hours.

Prepare medium hot coals for grilling or preheat broiler.

Alternately thread the chicken and onion pieces onto the bamboo skewers.

Place the skewers 5 inches from the heat and grill or broil the chicken, turning occasionally, until golden brown, about 6 to 8 minutes. You can also cook the skewers directly on top of a hot, oiled, stove-top grill pan.

Serve immediately.

Yield: 4 servings

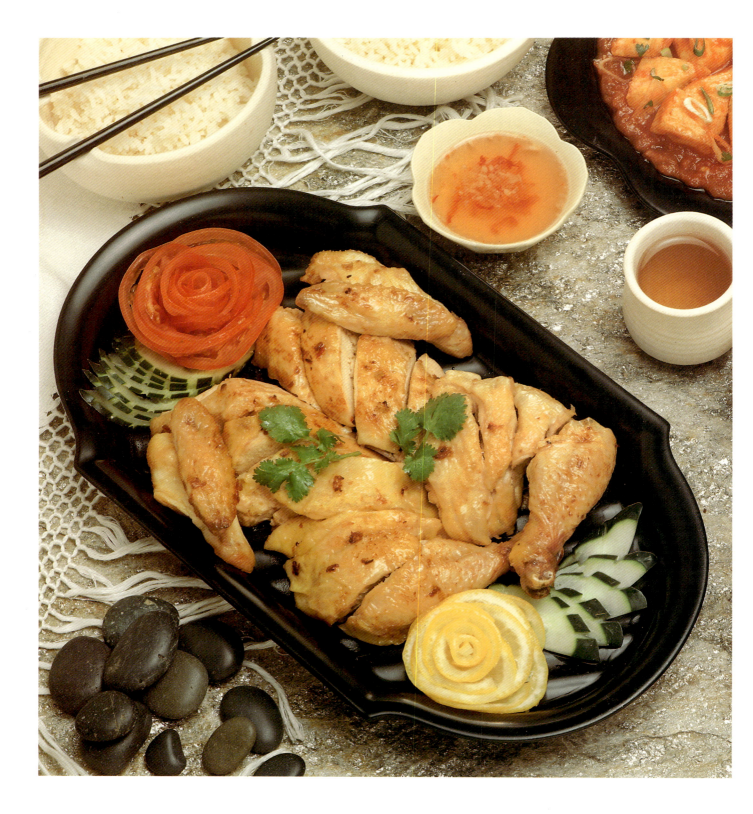

Roast Chicken with Lemongrass
Ga Nuong Xa

Roast chicken doesn't have to be boring. Gild it with spices—lemongrass, chile peppers, garlic, and shallots—and you have an exotic meal. The rich, golden brown, flavorful skin is achieved by basting the chicken with vegetable oil. Duck may replace the chicken in this recipe, in which case basting is unnecessary.

Nuoc Cham (page 29)
3 stalks fresh lemongrass
6 garlic cloves, crushed
4 shallots, sliced

2 fresh Thai or serrano chile peppers, seeded
1 tablespoon sugar
1/2 teaspoon salt

1 tablespoon *nuoc mam* or *nam pla* (Vietnamese or Thai fish sauce)
1 roasting chicken (about 4 pounds)
2 tablespoons vegetable oil

Prepare the *Nuoc Cham.* Set aside.

Peel and discard the outer leaves of the lemongrass. Using a sharp knife, cut off and discard the upper half of the stalks at the point where the leaves branch out. Thinly slice, then finely chop the trimmed stalks.

In a mortar or spice grinder, pound or grind the lemongrass, garlic, shallots, chilies, and sugar to a paste. Add the salt and fish sauce; blend well.

Rinse the chicken well and pat dry. Carefully loosen the skin on breast and legs of chicken by pushing your fingers between the skin and meat to form a pocket. Rub half of the lemongrass paste all over the meat under the skin. Rub the remaining paste all over the chicken skin and inside the cavity. Tuck the wings under the chicken and tie the legs together with twine. Set aside for 30 minutes.

Preheat oven to 425°F.

Place the chicken on a rack in a roasting pan. Roast for 15 minutes. Reduce the oven temperature to 375°F and continue roasting for 1 1/4 hours, basting the chicken occasionally with the oil and the pan juices. The chicken is done when it registers 180° to 185°F on a meat thermometer, or when a leg moves freely in its joint. Remove the chicken from oven and let it stand for 10 minutes.

To carve: Place the chicken breast side up and cut in half lengthwise. Cut off wings and legs. Remove the backbone on each half of the bird, then cut the backbone into bite-size pieces and reassemble on a serving platter. Cut each wing and leg into 2 or 3 pieces and arrange on either side of the backbone. Chop the remaining bird into bite-size pieces. Reassemble each half to its original shape.

Serve with an accompaniment of rice and *Nuoc Cham.*

Yield: 4 servings

MEAT

Braised Pork in Five-Spice Sauce
Thit Heo Thung

In northern Vietnam this country-style stew is usually made with pork shoulder or pork butt, though I find it equally delicious with top loin. Instead of the usual rice accompaniment, try serving it with strands of noodles to sop up all of the wonderfully rich, peppery sauce. This dish can be prepared in advance and reheated before serving.

I 1/2 cups chicken broth
I tablespoon light soy sauce
I tablespoon dark sesame oil
I tablespoon honey
I tablespoon tomato paste
I teaspoon Chinese five-spice powder

2 teaspoons *nuoc mam* or *nam pla*
 (Vietnamese or Thai fish sauce)
I tablespoon coarsely chopped garlic
 (about 6 medium cloves)
1/2 teaspoon salt
I teaspoon freshly ground black pepper

4 teaspoons peanut oil
3 pounds rolled, boneless, top loin pork
 roast, trimmed and tied, at room
 temperature
4 medium shallots, thinly sliced

Whisk together the chicken broth, soy sauce, sesame oil, honey, tomato paste, five-spice powder, and fish sauce in a medium-size bowl; cover and set aside.

Place the garlic, salt, and black pepper in a mortar or spice grinder, and pound or grind to a fine paste. Transfer the paste to a small bowl and stir in 2 teaspoons of the peanut oil. Rub the garlic mixture over the entire pork roast.

Heat the remaining 2 teaspoons of peanut oil in a Dutch oven or cast-iron skillet over medium-high heat. When the oil is very hot, carefully add the roast and brown it quickly on all sides, about 5 minutes. Reduce the heat to low, cover, and continue to cook for 45 minutes, basting occasionally with the pan juices.

Pour off all but I tablespoon of fat from the pan. Add the shallots and stir until aromatic and lightly browned, about 30 seconds. Add the five-spice sauce and turn the meat in the sauce to coat. As soon as the sauce comes to a boil, reduce the heat to medium, cover, and simmer for 15 minutes, turning the roast once or twice. The roast is done when an inserted instant-read thermometer reads 150°F.

Remove the roast to a cutting board and allow it to rest for 10 minutes. Cut the meat into thin slices and arrange them on a warm platter.

To serve, reheat the sauce and spoon it over the meat.

Yield: 4 to 6 servings

Beef Fondue with Vinegar
Bo Nhung Giam

In Vietnam, to celebrate special occasions, families often serve a seven-course dinner called Bo Bay Mon, *or "Beef in Seven Ways."*
All of the courses are made of beef and served in small portions; this Beef Fondue with Vinegar is one of them. To facilitate cutting the beef into
paper-thin slices, freeze it for one hour, or until partly frozen, before slicing.

ACCOMPANIMENTS
Anchovy and Pineapple Sauce (page 31)
 Assorted vegetable platter (page 21)
2 bundles *somen* (Japanese alimentary
 paste noodles), prepared according to
 directions on page 60
1 cup unsalted pan-toasted or
 dry-roasted peanuts, coarsely ground
8 ounces *banh trang* (rice-paper rounds),
 each 6 1/2 inches in diameter

BEEF PLATTER
1 1/2 pounds sirloin of beef or eye of
 round, trimmed of fat and sliced
 paper-thin across the grain
2 scallions (both green and white parts),
 minced
2 small onions, sliced and separated into
 rings
3 tablespoons vegetable oil
Freshly ground black pepper

BROTH
2 tablespoons vegetable oil
4 garlic cloves, minced
2 tablespoons chopped fresh lemongrass
6 thin slices fresh ginger
2 cups distilled white vinegar
1/4 cup sugar
1 1/2 tablespoons salt
2 scallions (both white and green parts),
 chopped

Prepare the accompaniments: Make the dipping sauce, vegetable platter, noodles, and peanuts; refrigerate all. Cover the rice papers with a damp cloth, followed by plastic wrap, and keep at room temperature until needed.

Prepare the beef platter: Arrange the beef slices in overlapping layers on 1 large-size or 2 medium-size platters. Garnish with the minced scallions and onion rings. Sprinkle the oil and black pepper over all. Cover with plastic wrap and refrigerate.

Prepare the broth: In a heavy nonreactive saucepan, heat the oil. Add the garlic, lemongrass, and ginger, and stir-fry until fragrant. Add the vinegar, sugar, salt, and 2 cups of water. Bring to a boil.

Transfer the broth to a tabletop fondue pot. Add the chopped scallions and maintain at a simmer.

To serve, pour the dipping sauce into individual bowls and place all of the prepared platters alongside the fondue pot.

To eat, dip each rice-paper round into a bowl of warm water to make it pliable and place it on a dinner plate. Add different ingredients from the vegetable platter, some noodles, and a teaspoon of the ground peanuts. Using chopsticks, dip a few slices of beef and onion rings into the simmering broth for about 1 minute, or until the beef loses its pinkness on the outside but is still rare inside. Remove the meat and add to the vegetable mound. Roll up the filled rice paper to form a neat package, then dip it in the dipping sauce and eat it by hand.

Yield: 4 to 6 servings

Ground Pork Omelet
Cha Trung

This sounds like an omelet, but it is more like an Egg Fu Yung in concept. The ground pork (or any kind of meat or seafood) is laced with eggs, shaped into a cake, then fried until golden brown. This quick, economical, and delicious concoction is served as a simple dinner with pickled cabbage, sliced fresh cucumbers, and soup. Cold leftover pork omelet makes for an excellent sandwich or may be added to fried rice.

Nuoc Cham (page 29)
1 pound ground pork
1 medium onion, chopped
2 scallions (both green and white parts), finely sliced

3 garlic cloves, chopped
1 tablespoon *nuoc mam* or *nam pla* (Vietnamese or Thai fish sauce)
4 eggs
2 tablespoons cornstarch

Freshly ground black pepper
2 tablespoons vegetable oil

Prepare the *Nuoc Cham*. Set aside.

In a large mixing bowl, combine the ground pork, onion, scallions, garlic, and fish sauce; mix well. Break the eggs over the mixture and gently combine. Do not beat the eggs. Add the cornstarch and ground pepper to taste. Fold in gently.

Heat the oil in a 9-inch nonstick omelet pan or skillet over high heat. When the oil is slightly smoking, gently pour the pork mixture into the pan. Reduce the heat to medium and let the mixture cook without disturbing it for 3 minutes.

When the edges turn brown, lift the edges of the omelet slightly with a spatula, so that the uncooked liquid gathered on top of the cake can run through to the bottom. Cook the omelet for about 7 minutes longer, or until the bottom is firm and nicely browned.

Slide the omelet onto a large plate; place another large plate over the omelet and invert the omelet onto it. Slide the omelet back into the skillet, uncooked side down, and cook for another 10 minutes. Transfer the omelet to a serving platter.

Cut the omelet into 2-inch squares. Serve with rice and *Nuoc Cham*.

Yield: 4 servings

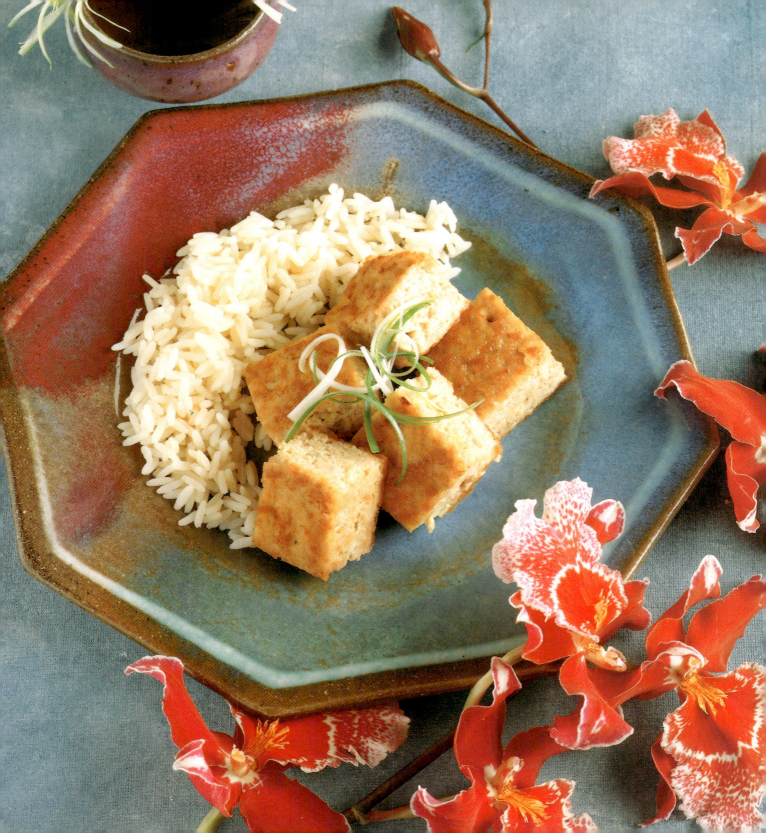

Vietnamese-Style Scrambled Eggs
with Chinese Sausage
Trung Ga Xot-Xet

When I was a schoolgirl, my mother used to pack my lunch box with overstuffed sandwiches filled with either Vietnamese sausages, pâtés, or these tasty scrambled eggs. Now, I enjoy serving scrambled eggs for breakfast with toasted bagels or as a light lunch with steamed rice and some refreshing slices of cucumber.

9 large eggs
3 scallions (both green and white parts), thinly sliced
3 links *lap chuong* (dried Chinese sausage), diced into 1/4-inch cubes

3 shallots, thinly sliced
2 teaspoons finely chopped garlic (about 4 medium cloves)
3 medium-size ripe tomatoes, or 8 plum tomatoes, cored and coarsely chopped

2 tablespoons *nuoc mam* or *nam pla* (Vietnamese or Thai fish sauce)
3/4 teaspoon sugar
1 tablespoon chopped coriander
Freshly ground black pepper

In a large mixing bowl, beat the eggs, using a fork or wire whisk, until light and foamy. Stir in the scallions.

In a large nonstick skillet, cook the sausage links over medium heat for 2 to 3 minutes, or until they are browned, then render some fat.

Add the shallots and garlic and stir-fry until fragrant, about 30 seconds. Add the chopped tomatoes and cook until they are soft and render some juice, about 1 minute. Add the fish sauce and sugar. Continue to cook until the tomatoes are slightly reduced, another 2 minutes.

Pour in the eggs. Cook, stirring gently with a rubber spatula, until the eggs are softly set but not runny, about 3 to 4 minutes. Remove the skillet from the heat, and stir in the coriander.

Transfer the eggs to a warm dish. Sprinkle with freshly ground black pepper to taste and serve.

Yield: 4 servings

Barbecued Spareribs
Suon Nuong

This is one of my favorite dishes. If you don't have a sturdy cleaver, ask the butcher to cut the ribs for you.

Caramel Sauce (page 30)
2 stalks fresh lemongrass
4 shallots

4 garlic cloves
2 small fresh Thai or serrano chile
 peppers

2 pounds lean spareribs, cut into
 individual ribs

Prepare the Caramel Sauce; set aside.

Peel and discard the outer leaves of the lemongrass. With a sharp knife, cut off and discard the upper half of the stalks at the point where the leaves branch out. Thinly slice, then finely chop the slices.

Combine the lemongrass, shallots, garlic, and chiles in a mortar or spice grinder and pound or grind to a paste. Stir the paste into the cooled caramel sauce.

Place the ribs in a large dish. Pour the sauce over the ribs and turn to coat evenly. Let the ribs marinate in the refrigerator for at least 1 hour or until ready to barbecue.

Drain the ribs, reserving the marinade for basting. On a hot grill over medium coals, cook the ribs for 45 to 50 minutes, depending upon thickness. Turn the ribs frequently and brush them with the marinade.

The spareribs may also be baked in a foil-lined roasting pan in a preheated 350°F oven. Turn and baste the ribs frequently for 30 to 35 minutes, then place them under the broiler for 5 more minutes on each side or until nicely glazed.

Serve as an appetizer or as part of a family meal accompanied by rice and pickled bean sprouts or pickled mustard greens.

Yield: 4 servings

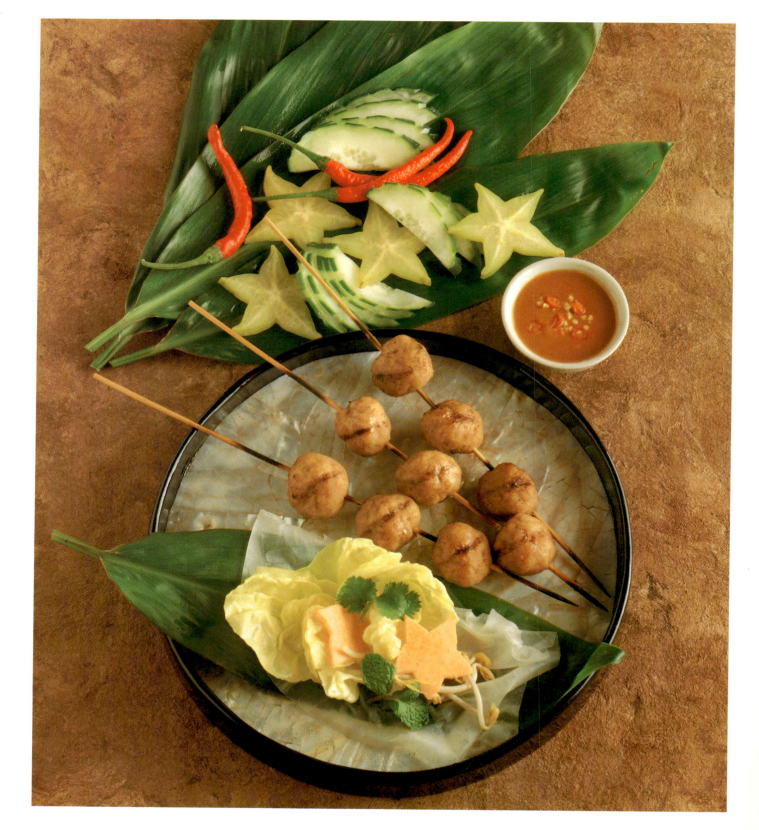

Nha Trang Skewered Meatballs
Nem Nuong

Although this dish is a specialty of the central region, it is enjoyed throughout the country. As in most classic Vietnamese dishes, it requires pounding the pork to achieve that certain crunchiness very much appreciated by food aficionados. I break with tradition here by using a food processor; I prefer the convenience, and the result is more than satisfying. If you are fortunate enough to find Chinese chives, include them in the vegetable platter for authenticity.

Peanut Sauce (page 30)
Assorted vegetable platter (page 21)
3 tablespoons Roasted Rice Powder (page 28)
8 ounces *bun* (thin rice vermicelli) or 2 bundles *somen* (Japanese alimentary paste noodles), prepared according to directions on page 60

8 ounces *banh trang* (rice-paper rounds), each 6 1/2 inches in diameter
1 1/2 pounds fresh ham, trimmed of excess fat
4 shallots, sliced
8 garlic cloves, sliced
2 tablespoons *nuoc mam* or *nam pla* (Vietnamese or Thai fish sauce)

2 teaspoons ground rock sugar or granulated sugar
Freshly ground black pepper
4 ounces pork fat
Vegetable oil
12 bamboo skewers, soaked in water for 30 minutes

Prepare the Peanut Sauce, vegetable platter, and Roasted Rice Powder.

Cover the rice papers with a damp cloth and then with plastic wrap, and keep at room temperature until needed.

Thinly slice the fresh ham. Place in a shallow dish and add the shallots, garlic, fish sauce, sugar, and pepper to taste; mix well.

Cover the dish and let it marinate for at least 30 minutes.

Before processing the meat, transfer the dish to the freezer for about 30 minutes. Place the partially frozen mixture in a food processor (avoid overloading the work bowl) and process to a completely smooth yet stiff paste. The paste should be sticky and spring back to the touch. Stop every now and then to scrape down the sides of the work bowl. Transfer the mixture to a mixing bowl.

Add the pork fat to the processor and blend to a fine paste. Add the meat paste to the processed fat, along with the Roasted Rice Powder and pulse briefly, only enough to blend. (If you overwork the paste, it will turn into mush.)

Pour a little oil into a bowl. Rub one hand with the oil, and with it, grab a handful of the meat mixture. Make a loose fist, squeezing out a small ball of mixture between your thumb and index finger; keep squeezing out until you have a round and smooth meatball. Using an oiled spoon, scoop it off your hand. Continue forming meatballs until all of the paste is used.

Thread the meatballs onto the bamboo skewers. Grill the skewered meatballs over a low charcoal fire, or under a broiler about 6 inches from the heat, for about 30 minutes, or until golden brown. Turn the meatballs occasionally so that they cook evenly.

To serve, pour the dipping sauce into individual bowls.

To eat, dip a rice-paper round into a bowl of warm water to soften and make it pliable. Place the paper on a dinner plate. Add different ingredients from the vegetable platter along with some noodles and a few meatballs. Roll up everything to form a neat package. Dip the roll in the Peanut Sauce and eat it by hand.

Yield: 4 to 6 servings

VEGETABLES

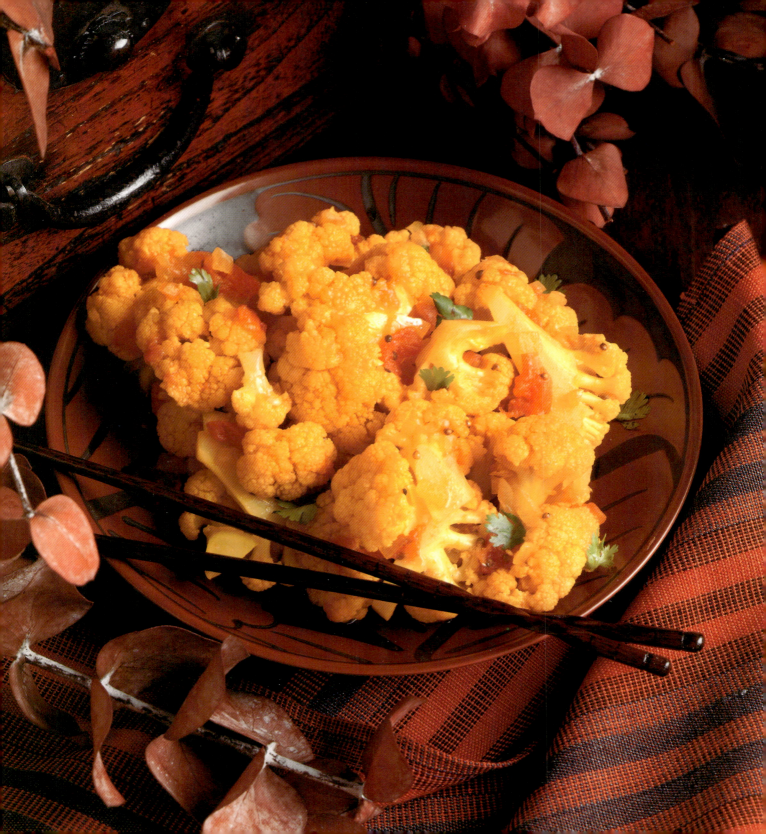

Stewed Cauliflower
Cai Hoa Thung

*As much as I like to munch on raw cauliflower, I enjoy this vegetable even more
when it is slowly cooked in a fragrant, spicy sauce that radiates a bright yellow hue from the turmeric that flavors it.
This wonderful dish makes a piquant accompaniment for grilled meats, mild fish, poultry, or pork.*

I head cauliflower (about 2 pounds)
1 1/2 tablespoons peanut oil
1 1/2 cups finely chopped onions, (about
 2 to 3 medium onions)
2 tablespoons finely chopped garlic
 (about 12 medium cloves)
2 tablespoons finely chopped fresh ginger
 (about a 2-inch piece)

2 large ripe tomatoes (about 1 1/4
 pounds), finely chopped
I tablespoon coriander seeds, crushed
3/4 teaspoon ground turmeric
4 fresh Thai or serrano chile peppers,
 finely chopped
2 cups hot chicken broth or hot water

1/4 cup *nuoc mam* or *nam pla* (Vietnamese
 or Thai fish sauce)
I teaspoon sugar
1/4 cup coarsely chopped fresh coriander
 leaves

Trim and cut the cauliflower into bite-size florets.

Heat the oil in a wok or large skillet over medium-high heat. Add the onions, garlic, and ginger, and sauté until the mixture is fragrant and tender, about 2 minutes. Add the tomatoes and cook until they are soft and release some juice, about 3 minutes.

Stir in the coriander seeds, turmeric, and chile peppers. Add the broth, fish sauce, and sugar. As soon as the mixture comes to a boil, add the cauliflower and stir to coat.

Lower the heat to medium, cover, and simmer, stirring occasionally until the cauliflower is tender, about 15 minutes.

Stir in the coriander leaves and serve immediately.

Yield: 4 to 6 side-dish servings

Crisp-Fried Bean Curd in Tomato Sauce
Dau Phu Sot Ca Chua

*This is one of the most sophisticated and tasty bean curd dishes ever invented.
Some Vietnamese cooks like to add fresh bacon for extra flavor, but I find it more delicate without it.*

Nuoc Cham (page 29)
1 pound firm bean curd (tofu)
Peanut oil, for frying
4 shallots, thinly sliced
4 garlic cloves, thinly sliced

4 large tomatoes (about 2 1/2 pounds),
 cored, peeled, seeded, and diced
2 tablespoons *nuoc mam* or *nam pla*
 (Vietnamese or Thai fish sauce)
1 teaspoon sugar

1/2 cup chicken broth or water
2 scallions (both green and white parts),
 thinly sliced
2 tablespoons shredded coriander
 Freshly ground black pepper

Prepare the *Nuoc Cham*. Set aside.

Dice the bean curd into 1-inch cubes. Drain on a double thickness of paper towels.

In a skillet, add oil to a depth of 1/2-inch and heat over medium heat. Add the bean curd and gently fry, without crowding, until crisp and golden brown on both sides, about 8 minutes. Using a slotted spoon, remove the bean curd and drain on paper towels.

Remove all but 2 tablespoons of oil from the pan. Heat the oil over medium heat. Add the shallots and garlic and fry until fragrant, about 1 minute. Add the tomatoes, fish sauce, and sugar and cook for 1 minute. Reduce the heat to low and simmer for 15 minutes.

Add the chicken broth and bring the mixture to a boil. Return the bean curd to the pan and toss to coat evenly with the sauce. Reduce the heat to low and simmer for 5 minutes. Stir in the scallions and coriander. Transfer to a warm serving platter.

Sprinkle with black pepper to taste and serve with plain rice and *Nuoc Cham*.

NOTE: For a much simpler but no less delicious dish, substitute *Nuoc Cham* (page 29) for the tomato sauce. Its spiciness and tang will cut the richness of the fried bean curd.

Yield: 4 side-dish servings

Steamed Okra in Chile Sauce
Muop Luoc

*Just as in the southern United States, okra is a very popular vegetable in southern Vietnam. Instead of frying, however,
Vietnamese cooks prefer to steam this vegetable and serve it with a lively sauce comprised of chiles, garlic, sugar, lime juice, and lots of fresh basil.
The acidity in the sauce dramatically offsets okra's somewhat gluey texture.*

1 teaspoon minced garlic (about 2 medium cloves)

2 fresh Thai or serrano chile peppers, coarsely chopped

1 1/2 teaspoons sugar plus 1 tablespoon sugar

2 tablespoons rice vinegar, or distilled white vinegar

2 tablespoons fresh lime juice

2 1/2 tablespoons *nuoc mam* or *nam pla* (Vietnamese or Thai fish sauce)

1 pound fresh okra, trimmed

2 tablespoons fresh Thai basil or regular sweet basil leaves, finely shredded

Make the chile sauce: Combine the garlic, chile peppers, and 1 1/2 teaspoons of sugar together in a mortar or spice grinder and pound or grind the mixture to a fine paste. Transfer the paste to a small bowl and add the remaining 1 tablespoon of sugar, vinegar, lime juice, and fish sauce, along with 1/4 cup warm water. Stir until the sugar dissolves. There should be about 1/2 cup of sauce; set aside.

Trim off and discard the stem ends of the okra pods, then rinse well and drain.

Bring a large pot of salted water to a rapid boil over medium-high heat. Add the okra and cook until crisp yet tender, about 3 minutes. Take care not to overcook or the okra may become slimy in texture. Transfer to a colander and drain well.

Arrange the okra on a serving platter and immediately top with the sauce. Sprinkle with shredded basil and serve immediately.

Yield: 4 side-dish servings

Roasted Eggplant Stir-Fry
Ca Tim Nuong Xao Dam Ot

This is one of my favorite eggplant dishes. The grilled eggplant yields a delicious smoky and nutty flavor that is enhanced by garlic and fresh basil. Choose small but firm eggplants for this purpose; the Japanese variety is best.

1 1/2 teaspoons sugar
2 tablespoons distilled white vinegar
1 tablespoon *nuoc mam* or *nam pla* (Vietnamese or Thai fish sauce)

2 large Thai or serrano chile peppers, seeded and shredded
2 pounds firm eggplants
3 tablespoons peanut oil
8 garlic cloves, crushed

1/4 cup shredded fresh Thai or regular sweet basil
Freshly ground black pepper

Combine the sugar, vinegar, fish sauce, and chiles in a small bowl; set aside.

Prick the eggplants with a fork. Grill them over medium coals or a gas flame, turning constantly until the flesh is soft and the skins are charred, about 4 minutes. If using an electric stove, place the eggplants directly on the burners. Transfer to a rack and allow to cool. Peel and discard any charred skin. Cut the eggplants into 2 1/2 x 1/2-inch strips.

Heat the oil in a wok or large skillet until very hot. Add the garlic and stir-fry for a few seconds. Add the eggplants and sauté for 2 minutes, tossing to coat the eggplants with the sauce. Add the basil and remove from the heat.

Transfer to a warm serving platter. Sprinkle with black pepper and serve with rice as part of a shared family meal.

Yield: 4 side-dish servings

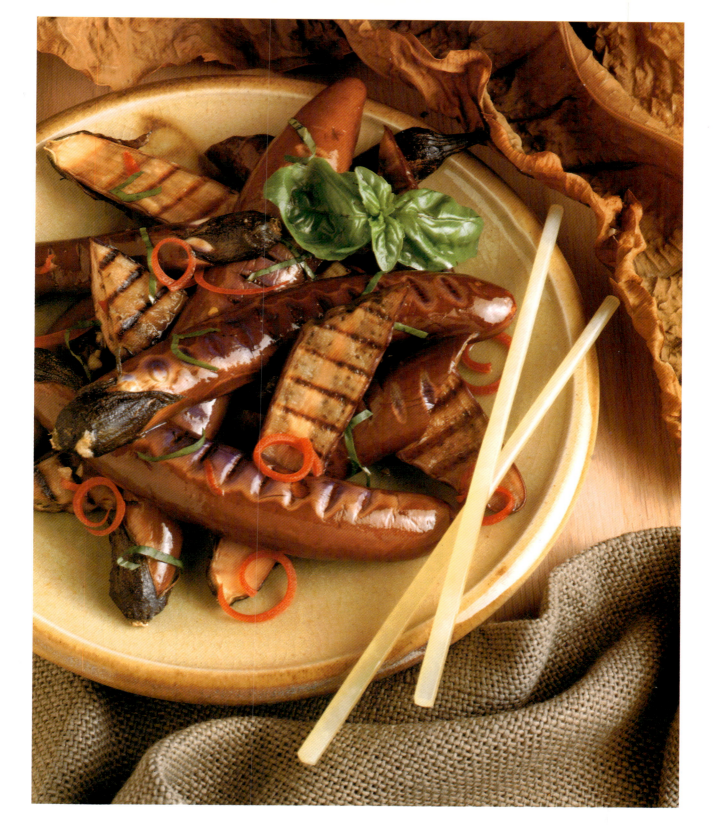

Stir-Fried Water Spinach with Garlic
Rau Muong Xao Toi

The Vietnamese love water spinach for its texture when cooked—an interesting contrast between crunchy stems and gently wilted leaves.
Fresh spinach or watercress may be substituted if water spinach is not readily available.

Nuoc Cham (page 29)
2 pounds water spinach or regular spinach
1/4 cup peanut oil

8 garlic cloves, minced
1 tablespoon *nuoc mam* or *nam pla*
(Vietnamese or Thai fish sauce)

Freshly ground black pepper

Prepare the *Nuoc Cham;* set aside.

Wash the spinach thoroughly. If using water spinach, pound the stems flat and cut them into 2-inch sections. Keep the stems and leaves on separate plates.

Heat the oil in a wok or large cast-iron skillet over high heat. Add the garlic and fry until fragrant. Add the spinach. (If using water spinach, add the stems first and stir-fry for 1 minute before adding the leaves.) Continue to stir-fry until wilted. Add a splash of water if the greens seem too dry, then stir in the fish sauce. Transfer to a warm serving platter, sprinkle with black pepper, and serve with *Nuoc Cham.*

VARIATION: For a main course, add marinated beef or shrimp to this stir-fry. The beef or shrimp should be briefly stir-fried, then transfered to a platter. Use the juices from the meat or shrimp instead of water when cooking the spinach and add the meat or shrimp to the spinach at the very end, just to heat through.

Yield: 4 side-dish servings

Tangy Bean Curd & Watercress
Cai Son Va Dau Phu Luoc

This salad excites the palate with opposite textures—the softness of bean curd and crunchiness of watercress—and is delicately complemented with the smooth nuttiness of sesame oil. My mother often served this salad as a side dish to Catfish in Black Pepper Sauce, but I find it equally good with grilled meats or stews.

1 1/2 tablespoons sugar
2 large cloves garlic, finely chopped
1 fresh Thai or serrano chile pepper
2 1/2 tablespoons *nuoc mam* or *nam pla* (Vietnamese or Thai fish sauce)
1 1/2 tablespoons fresh lemon juice

1 1/2 tablespoons rice vinegar, or distilled white vinegar
3/4 cup chopped and seeded tomato (about 1/2 pound tomatoes)
1 1/2 tablespoons shredded fresh coriander leaves

1 teaspoon dark sesame oil
2 bunches watercress, washed and cut crosswise into thirds
2 (8-ounce) blocks firm bean curd (tofu), cut into 2 x 1-inch rectangles, about 1/2-inch thick

Using a spice grinder, process the sugar, garlic, and chile pepper to a smooth paste.

Transfer the paste to a medium bowl and add the fish sauce, lemon juice, and vinegar. Stir until the sugar is dissolved. Mix in the chopped tomatoes, coriander, and sesame oil. Set aside. (This mixture can be prepared up to 2 hours ahead if covered and refrigerated. Bring it to room temperature before serving.)

Bring a large pot of water to a boil over high heat. Add the watercress. Bring back up to a boil and cook for 30 seconds. Drain the watercress, refresh under cold running water, then drain again. Squeeze to remove excess water.

Arrange the watercress on a platter and top with the tofu. Drizzle with tomato dressing and serve at room temperature.

Yield: 4 side-dish servings

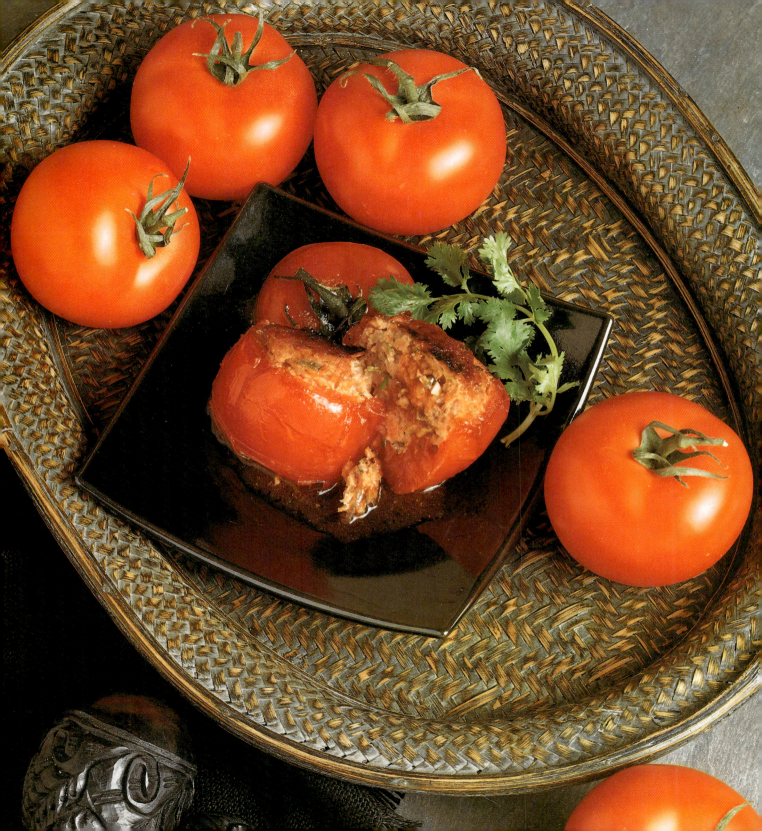

Stuffed Tomatoes
Ca Chua Nhoi Thit

This colorful and tasty dish is very easy to make.

Nuoc Cham (page 29)

SAUCE
1/3 cup chicken broth or water
I tablespoon *nuoc mam* or *nam pla*
 (Vietnamese or Thai fish sauce)
1/4 cup oyster sauce
I tablespoon sugar
I teaspoon tomato paste

TOMATOES AND FILLING
4 large tomatoes (about 2 1/2 pounds)
2 dried Chinese mushrooms
1 1/2 teaspoons dried tree ear
 mushrooms
1/2 ounce cellophane (bean thread)
 noodles
8 ounces ground pork
4 garlic cloves, chopped

2 shallots, thinly sliced
2 scallions (both green and white parts),
 thinly sliced
1/4 teaspoon sugar
2 teaspoons *nuoc mam* or *nam pla*
I egg, lightly beaten
2 tablespoons peanut oil
 Freshly ground black pepper

Prepare the *Nuoc Cham;* set aside.

Combine all of the sauce ingredients in a small bowl; set aside.

Cut off the stem end of each tomato. Using a spoon, gently scoop out the pulp. Discard the tops and pulp. Dry the insides of the tomatoes with paper towels.

Soak the mushrooms in hot water and the noodles in warm water for 30 minutes. Drain well. Squeeze out the excess water from the mushrooms and cut off and discard the stems. Mince the mushroom caps. Coarsely chop the noodles.

In a mixing bowl, combine the chopped mushrooms and noodles with the pork, half of the garlic, the shallots, scallions, sugar, fish sauce, and egg. Blend together using your hands, then set aside to marinate for 30 minutes.

Stuff the pork mixture into the tomatoes, pressing firmly. Smooth off the top into a mounded dome.

Heat the oil in a wok or skillet over medium heat. Place the stuffed tomatoes, stuffing side down, in the hot oil. Cover the wok and fry for 5 minutes. Using a large spatula, gently turn the tomatoes (try not to break the skins) to meat side up and cook for 3 minutes longer.

Make a small space in the center of the wok. Add the reserved garlic and fry until fragrant. Stir the reserved sauce mixture and pour into the wok. Bring the sauce to a rapid boil. Reduce the heat to low and simmer, covered, for 15 minutes, turning the tomatoes frequently to coat with the sauce.

The tomatoes are ready when the stuffing has absorbed half of the sauce and the tomatoes are nicely glazed. Transfer to a serving platter and sprinkle with black pepper.

Serve with plain rice and *Nuoc Cham.*

Yield: 4 side-dish servings

Stir-Fried Green Beans with Bean Curd
Dau Xao

This delicious vegetable dish is lightly flavored with curry powder, a spice borrowed from the Indian kitchen. Cooked in a flash, it is simple yet satisfying. This side dish can be transformed into a main meal by adding sautéed shrimp or chicken.

$^1/_3$ cup chicken broth
1 $^1/_2$ tablespoons *nuoc mam* or *nam pla*
 (Vietnamese or Thai fish sauce)
$^1/_2$ teaspoon sugar
$^1/_4$ teaspoon freshly ground black pepper
2 teaspoons peanut oil

$^1/_2$ medium onion, sliced into thin
 slivers
$^1/_2$ pound green beans, trimmed and
 cut in half
1 tablespoon finely chopped garlic
 (about 5 to 6 cloves)

1 teaspoon curry powder
$^1/_2$ pound firm bean curd (tofu), cut
 into $^3/_4$-inch cubes

Mix together the chicken broth, fish sauce, sugar, and black-pepper in a small bowl, stirring until the sugar is dissolved; set aside.

In a wok or large skillet, heat the oil over medium-high heat. Add the onion, green beans, and garlic and sauté until the onion is limp, about 2 minutes. Stir in the curry powder and the reserved seasoning mixture. Cover and cook until the green beans are crisp yet tender, about 3 minutes.

Add the bean curd, gently stirring to coat with the sauce. Cook until it is just heated through, about 1 minute. Remove from the heat and serve immediately.

Yield: 2 to 4 side-dish servings

DESSERTS

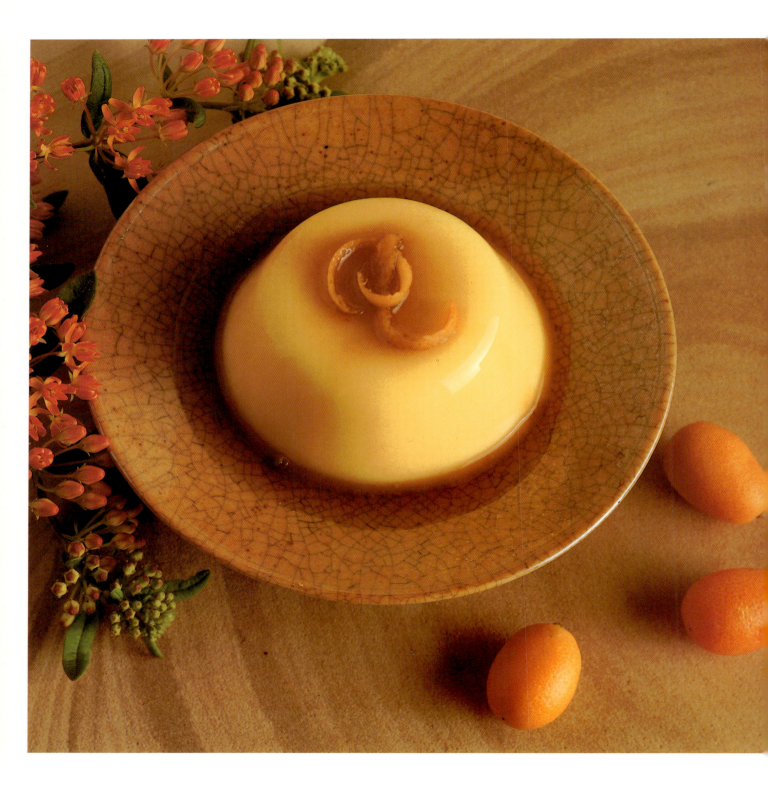

Coconut Flan with Caramel
Banh Dua Ca Ra Men

*This is the ultimate coconut dessert—an adaptation of the classic crème renversée, or flan au caramel.
The technique used is distinctively French but the flavors are all Vietnamese. This custard is at its best when prepared a day in advance
and refrigerated so the flavors can mellow. If you just can't wait, you might try the Vietnamese method of rapid cooling for dishes:
place a small scoop of shaved ice on top of each custard before serving.*

CARAMEL
1/4 cup sugar
1/4 cup hot water

CUSTARD
I cup fresh or canned coconut milk
I cup milk

1/4 cup sugar
4 eggs
I teaspoon vanilla extract

Preheat the oven to 325°F.

Prepare the caramel: In a small heavy saucepan, cook the sugar over low heat until brown, swirling the pan constantly. Stir the hot water into the caramel, being careful to guard against splattering (the mixture will bubble vigorously). Boil the mixture, swirling the pan occasionally, until the sugar is thoroughly dissolved, about 2 minutes.

Pour the caramel syrup into a I-quart soufflé dish or 5 (4-ounce) ramekins. Tilt the molds to coat the entire inner surface of the dishes.

Prepare the custard: Combine the coconut milk, milk, and sugar in a medium saucepan over low heat. Scald until the sugar dissolves completely. Remove from the heat.

In a large bowl, whisk the eggs and vanilla. Gradually whisk the hot coconut milk mixture into the eggs, blending thoroughly.

Using a fine sieve, strain the custard into a bowl. Carefully pour into the caramel-lined soufflé dish or ramekins. Line a large roasting pan with 2 layers of paper towels (see Note). Place the soufflé dish in the roasting pan and add enough hot water to reach halfway up the side of the dish.

Bake on the center rack of the oven for 50 minutes (30 minutes if using ramekins) or until a knife inserted in the center comes out clean. Be careful not to let the water boil and do not disturb the custard while baking. This is the only "secret" to producing a smooth and velvety custard.

Remove the soufflé dish immediately from the hot water and allow to cool in a cold-water bath. Refrigerate until thoroughly chilled.

To serve, run a knife around the edge of the custard and turn out onto dessert plates. Serve with shaved ice or whipped cream, if desired.

NOTE: The paper towels in the roasting pan serve two purposes. First, they allow the hot water to circulate under the soufflé dish while baking to distribute the heat evenly; second, if using small ramekins, it stabilizes them and lessens their movement during baking.

Yield: 5 servings

Sesame Cookies
Banh Me

A close cousin of the popular Chinese almond cookies, this Vietnamese version is much lighter and more flavorsome.
They are a delightful treat with hot tea.

3/4 cup toasted sesame seeds
2 1/4 cups all-purpose flour, sifted
1 teaspoon baking powder
1/2 teaspoon baking soda

1 1/2 cups vegetable shortening
1 cup sugar
2 whole eggs
1 teaspoon vanilla extract

All-purpose flour, for dusting
1 egg yolk mixed with 1 teaspoon water

Preheat the oven to 350°F. Line 2 cookie sheets with parchment paper.

Coarsely grind 1/2 cup of the sesame seeds and combine with sifted flour, baking powder, and baking soda.

In a mixing bowl, cream the shortening and sugar until fluffy. Add the eggs, one at a time, beating until smooth after each addition. Add the vanilla and stir to combine. Add the dry ingredients to the creamed mixture, a little at a time, mixing well after each addition. The dough should be moist and pull away from the sides of the bowl.

Dust a work surface with about 1/4 cup flour. Knead the dough to form a smooth ball.

To shape each cookie, roll 1 tablespoon of dough into a ball. Press lightly with the palm of your hand to form a 1 1/2-inch round. Place the cookies 2 inches apart on the baking sheets; freeze for 20 minutes.

Brush the cookies with the egg wash. Press the reserved sesame seeds into the dough. Bake for 15 to 20 minutes or until lightly browned. Remove and allow to cool.

Sesame cookies can be stored for up to 2 weeks in an airtight container.

Yield: 50 cookies

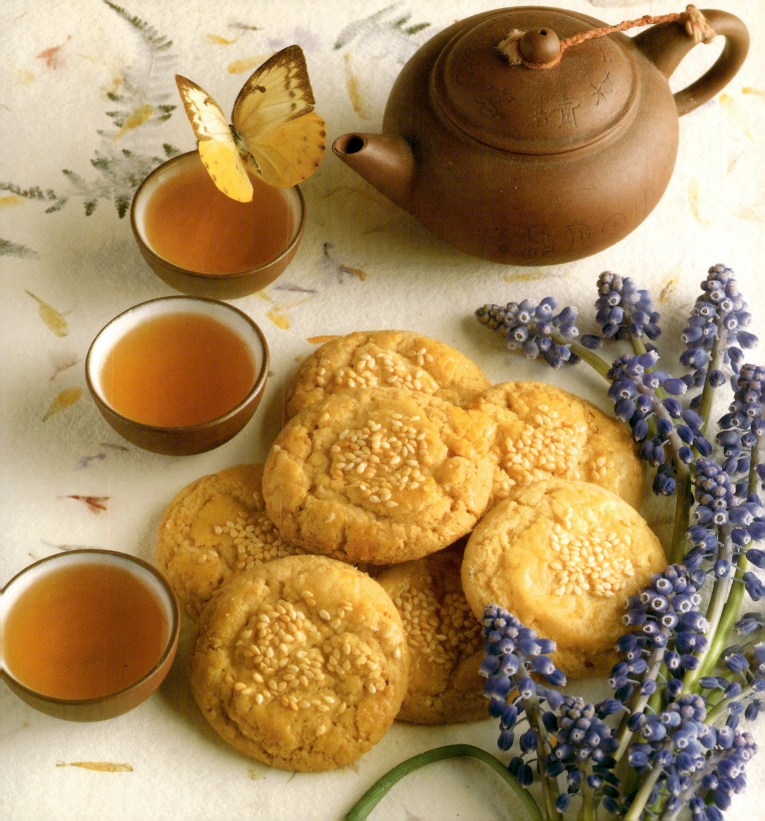

Poached Mangoes in Gingered Syrup
Xuoi Nau Nuoc Gung

As a mango lover, I'm very fond of this refreshing dessert, which bursts with tropical flavors. It is easy to prepare and can be served at room temperature or chilled. For a pretty presentation, thinly slice each mango lengthwise, fan the slices out on a dessert plate, and decorate with some of the syrup.

2 ripe firm mangoes
1/2 cup sugar

2 teaspoons finely grated, peeled fresh ginger (about a 2/3-inch piece)

Fresh mint sprigs, for garnish

Peel the mangoes. Using a sharp knife, halve each mango lengthwise, avoiding the elongated pit. Remove and discard the pits and set the mango halves aside.

In a large skillet over a medium-high heat, cook the sugar and 2 tablespoons of water for about 4 minutes, until the mixture smokes slightly, then turns a mahogany brown color. Remove from the heat and carefully pour in 1 1/2 cups of hot water. (Be careful as the mixture may splatter.)

Return the skillet to a low heat and simmer for 2 minutes. Stir in the ginger, mangoes, and turning only once, simmer until the fruit becomes fork tender, about 15 minutes. Transfer the mangoes to a shallow dish and allow to cool.

Bring the syrup to a boil and cook until it is reduced to about 1 cup. Strain the syrup over the cooled mangoes and allow the entire dish to cool.

Serve at room temperature, garnished with sprigs of fresh mint. Or cover and refrigerate until well chilled, about 3 to 4 hours.

Yield: 4 servings

Bananas in Coconut Milk
Che Chuoi

This simple yet satisfying dessert is very popular in Vietnam. Since most Vietnamese do not eat dessert right after a meal, this sweet soup is often served as a snack in the late afternoon. As young children, my sister and I enjoyed that time of day most, when our mother would treat us to sweet soups bought from a street vendor. This dessert is at its best when served warm.

1/4 cup very small tapioca pearls
3 cups fresh or canned coconut milk

1/3 cup sugar
4 large ripe but firm bananas

2 tablespoons toasted sesame seeds

In a bowl, cover the tapioca pearls with warm water and set aside to soak for 20 minutes. Drain.

Combine the coconut milk, sugar, and 2/3 cup of water in a 3-quart saucepan. Bring to a boil, taking care that the liquid does not boil over. Reduce the heat to low and simmer.

Peel the bananas and cut into 2-inch lengths. Add the banana pieces and drained tapioca pearls to the coconut milk mixture in the saucepan. Partially cover the pan and let simmer for 10 to 15 minutes, or until the tapioca pearls are clear.

Ladle the banana-coconut milk mixture into individual serving bowls. Sprinkle with the sesame seeds. Serve hot or warm.

NOTE: For a richer taste, float a tablespoon or two of unsweetened coconut cream on top of this dessert. Coconut cream is the thick layer found on top of canned, unsweetened coconut milk. Do not shake the can before opening.

Yield: 4 to 6 servings

Coconut Tartlets
Banh Dua Nuong

These toothsome little tarts with a buttery-sweet soft crust are my favorites. The crust is similar to the French pâte sucrée *but has the consistency of a rich sugar-cookie dough. It virtually melts in your mouth. If you don't have tartlet pans, use small brioche pans or a 9-inch tart pan.*

DOUGH
1/4 cup vegetable shortening, or 4
 tablespoons (1/2 stick) softened butter,
 cut into pieces
2 tablespoons sugar
I egg yolk
1/2 teaspoon vanilla extract
3/4 cup all-purpose flour, sifted
1/2 teaspoon baking powder

FILLING
2 cups grated fresh coconut or packaged
 sweetened shredded coconut
2 tablespoons sugar
4 tablespoons (1/2 stick) softened butter,
 cut into pieces
I egg yolk
2 tablespoons heavy cream
1/2 teaspoon vanilla extract

GLAZE
I egg yolk
I tablespoon butter, melted and cooled

Preheat the oven to 350°F.

Prepare the dough: In a mixing bowl, beat the shortening and sugar until creamy and fluffy. Stir in the egg yolk and vanilla; mix to combine. Add the flour and baking powder and mix well. Knead the dough until smooth.

Divide the dough into 6 portions. Place each portion in a 3-inch tartlet pan and press to line the mold. Refrigerate until ready to use.

Prepare the filling: Combine the coconut, sugar, and butter in a mixing bowl. (Omit the sugar if using canned or packaged sweetened coconut shreds.) Knead to form a soft mixture. Add the egg yolk, cream, and vanilla and, using your hands, blend well to form a smooth, soft paste.

Divide the mixture into 6 portions. Fill each tartlet with I portion of the coconut mixture; smooth off the top. Place the tartlets on a cookie sheet.

Prepare the glaze: Beat the egg yolk lightly. Stir in the melted butter.

Bake the tartlets for 15 minutes. Brush the surface and crust edges of the tartlets with the glaze. Return to the oven and bake for 5 minutes longer.

Turn the oven to broil. Run the tartlets under the broiler and broil until the glaze becomes shiny and the crust and coconut turn golden, about 30 seconds.

Cool the tartlets slightly before removing them from their molds. Serve warm or cold.

Yield: Six 3-inch tartlets

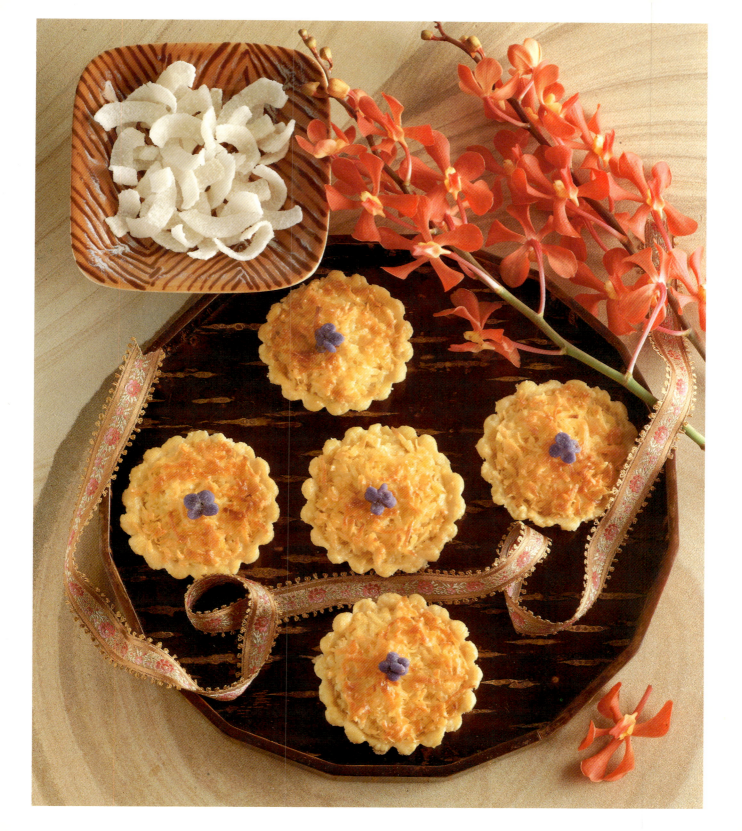

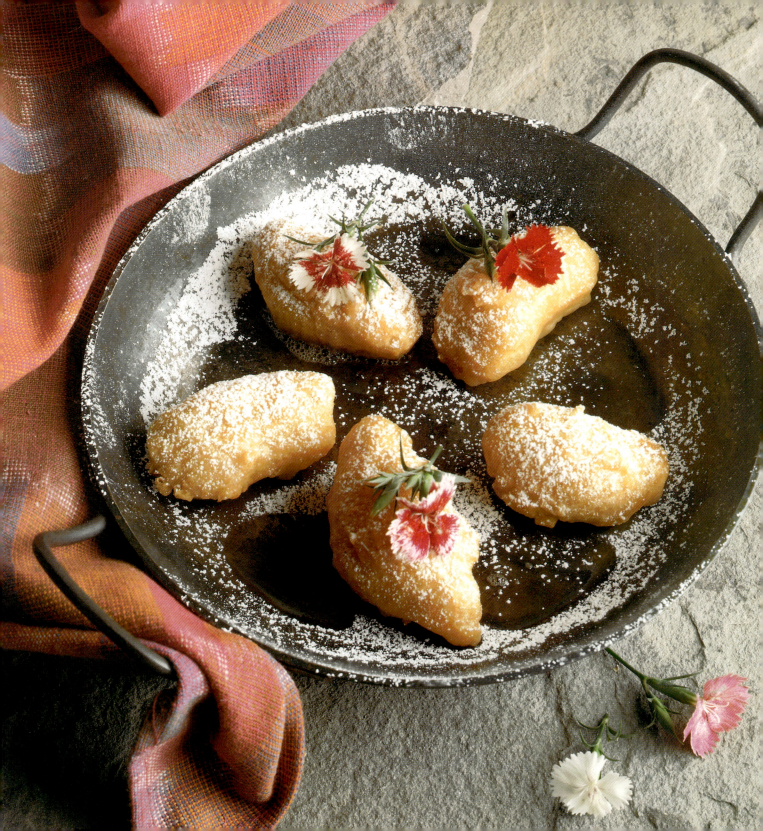

Fried Stuffed Bananas
Chuoi Chien

In France, every Vietnamese restaurant serves fried bananas. They are generally served flambéed,
a method dear to the French and adopted by the Vietnamese. To make fried bananas more interesting, I like to stuff them with pistachio or hazelnut paste
(available at specialty stores) and flambé them with rice wine. The result is a heavenly dessert as is, but it may also be served with ice cream.

2/3 cup all-purpose flour, sifted
1/4 cup cornstarch, sifted
2 teaspoons sugar
 Pinch of salt

1 teaspoon baking powder
1 tablespoon vegetable oil
4 large ripe but firm bananas
1/4 cup pistachio or hazelnut paste

Vegetable oil, for deep-frying
Cornstarch, for coating
1/3 cup rice wine or rum
Confectioners' sugar, sifted

Combine the flour, cornstarch, sugar, salt, and baking powder in a large bowl. Make a well in the center and gradually add 2/3 cup plus 1 tablespoon water, mixing well to make a smooth batter. Add the vegetable oil and stir until smooth. Refrigerate the batter for at least 1 hour.

Peel the bananas and halve crosswise. Split each half lengthwise and spread with 1/2 tablespoon of the pistachio paste. Take care to stuff the banana pieces neatly so the paste will not fall out during cooking.

In a wok or heavy skillet, add oil to a depth of 3 inches and heat to 375°F. Dredge the bananas in cornstarch; shake off any excess. Dip the stuffed bananas, a few at a time, in the batter. Carefully add a few pieces at a time to the hot oil. Fry, turning once, for 3 to 4 minutes, or until golden brown and crisp. Drain on paper towels. Transfer to a flameproof dish.

Place the liquor in a deep 8-ounce ladle and heat gently over a medium flame until the spirit comes to a boil and ignites instantly, about 2 minutes. Quickly pour the flaming liquor over the banana fritters. Using a long fork and spoon, carefully turn each fritter to coat with the flaming liquor.

As soon as the flames subside, sprinkle the dessert with sifted confectioners' sugar and serve.

NOTE: If you are using an electric burner, you will need to ignite the liquor with a match.

Yield: 4 servings

APPENDIX
The Vietnamese Kitchen

BASIC TOOLS AND EQUIPMENT

The traditional Vietnamese kitchen is a simple affair; it has far less equipment and tools than the Western kitchen. With a wok, a cleaver, a chopping block and a mortar and pestle, a Vietnamese cook can work wonders with whatever ingredients he or she is given.

Therefore, for you to prepare the dishes described in this book, there's no need to invest in a whole new set of cooking utensils. Your kitchen probably already has everything you need. A skillet can be used in place of a wok. A food procesor, blender, or spice grinder can replace a mortar and pestle and will also make your work easier.

The following basic serving pieces should be enough to give your table a Vietnamese accent: rice bowls, small saucers for dipping sauces, Oriental soup bowls (for noodle soups and salads), chopsticks, and porcelain spoons (porcelain is preferred because it does not absorb as much heat as metal). All of these items are usually available at Asian markets.

COOKING METHODS

Besides boiling, deep-frying, stir-frying, steaming, and roasting, two very strong Vietnamese culinary traditions are grilling over charcoal and simmering in a plain or spicy caramel sauce.

Before cooking, cut-up meats are generally marinated with spices and Vietnamese fish sauce (*nuoc mam*) for thiry minutes or more. The purpose of this preseasoning is to enhance the taste of the food as well as to preserve the vitamins and protein content in the meat, while retaining its tenderness and delicacy.

The French term *mise-en-place* aptly descibes the preparation steps needed before the final assembly of a recipe. Its literal meaning implies that all ingredients must be in a ready-to-cook state before the actual cooking takes place. For most Vietnamese dishes, more time is spent over the cutting board than over the stove. Any dehydrated foodstuffs, such as dried mushrooms or cellophane noodles, must be reconstituted well in advance of cooking. Vegetables, meats, fish, and seasonings must be cut into the appropriate size and shape for each dish. All the ingredients should be made ready and kept easily accessible. A complete *mise-en-place* is essential, as the cooking time of most dishes (especially stir-fries) is very short, with little time available to do last-minute preparation.

FRESH VEGETABLES

ASIAN EGGPLANT (*ca tim*) Also known as a Chinese eggplant, this long, thin, seedless lavender variety has a sweet flavor and no hint of bitterness. Small firm ones are considered the best. Unlike Western eggplant, they do not require peeling, salting, or rinsing.

BAMBOO SHOOTS (*mang*) Bamboo shoots fall into 2 categories: winter and spring. Winter shoots are best (Ma Ling or Companion brands preferred); they are dug up from the cracked earth before the shoots grow to any great length or size, making them extra tender and tasty. Spring shoots are longer and more stringy. In Asian markets, look for bamboo shoots that are kept in large plastic tubs; although they are also processed, they do not have a tinned taste (unlike canned shoots).

Pickled or "sour" bamboo shoots (*mang chua*) are fresh shoots preserved in brine. They are sold shredded or sliced in vacuum-packed bags. Use for stir-fries and hearty soups.

BEAN CURD/TOFU (*dau hu*) Known in the United States as tofu, the pressed bean curd of the soybean contains all the essential amino acids, is low in calories, and cholesterol free. It is flavorless but blends beautifully with other ingredients. You can do absolutely anything with bean curd: deep-fry, sauté, steam, bake, simmer, broil, or puree. It comes in three textures: soft, added to soups or steamed dishes where cooking time is brief; semi-soft, used in stir-fries; and firm, for stuffing and deep-frying.

If bean curd is not to be used the same day, it should be put in a container with enough water to cover and then refrigerated. Replace the water each day. Cared for in this way, bean curd will keep for a week or longer. It is available in supermarkets or Oriental markets.

BEAN SPROUTS (*gia*) Mung bean sprouts, the most widely available variety, can be found almost anywhere. Never use canned bean sprouts; they don't have the characteristic crunchy texture. You can also grow your own sprouts from dried mung beans. They are eaten raw, added to soups or stir-fried. They will keep in the refrigerator for up to 3 days if kept covered with water. In preparing fresh bean sprouts, keep in mind that they contain mostly water. So when stir-frying bean sprouts, do it quickly over very high heat, or they will release water and thin out the sauce.

CHINESE CABBAGE, FLOWERING (*cai xanh*) Distinguished by its yellow flowers and by its firm, small-stemmed stalks and crisp green leaves, this variety is considered the best of Chinese cabbages and is much prized by Vietnamese cooks. The taste is pleasant and mild and the texture tender but crisp. The stems must be peeled. Substitute Italian broccoli rabe (rapini).

CHINESE CABBAGE, SWATOW MUSTARD (*cai tau*) Also known as mustard greens, this vegetable resembles head lettuce in size and shape but differs in that the leaves wrapping the heart are thick stalks. This variety has a particularly sharp flavor, adding a wonderful clean taste when combined with other ingredients. However, after parboiling, the stalks become tender and succulent and the assertive flavor gets milder. Cut the stems into strips before cooking.

Pickled or "sour" mustard greens (*cai chua*) are the young tender hearts of mustard green cabbage preserved in brine. They are sold vacuum-packed in plastic bags. Use for stir-fries and soups.

CHINESE FLOWERING CHIVES (*hoa he*) These are the thin, stiff flowering stems from Chinese chives. They are distinguished by a single, conical bulb at the tip of each stem. Sold fresh by the bunch, the stalks are tender and mild to eat. Select young stems with small, hard, tight flower heads; those with open flowers are considered fibrous and too old to eat. Refrigerate, wrapped in a plastic bag, for up to 3 or 4 days. Cut the flower and stem into 2-inch lengths and discard the bottom inch or so. Use in soups, salads, stir-fries, or wherever an onion flavor is desired.

CHINESE KALE/BROCCOLI (*cai lan*) This vegetable is distinguished from the other cabbages by clusters of white flowers and white haze on the leaves. It has smooth, round stems that are tender, succulent and flavorful. The stems must be peeled. Stir-frying enhances most of the good points of this vegetable. Substitute Western kale.

DAIKON (*cu cai trang*) Also known as Oriental white radish, this root is distinguished by its large cylindrical size (similar to a carrot), with smooth skin and whitish color. The flesh is crisp, juicy, and mildly pungent and absorbs the flavors of soups and stews. It is also consumed raw in salads or pickled. Substitute white turnip.

JICAMA (*cu dau*) Jicama is a brown-skinned root vegetable resembling a turnip. The crisp, delicious white flesh tastes like a cross between a juicy pear, a crunchy water chestnut, and a starchy potato. It must be peeled and may be eaten raw in salads or cooked. Jicama is available in Southeast-Asian and Caribbean green-grocers as well as many supermarkets.

LONG BEANS (*dau dua*) As the name suggests, these beans can measure up to 2 feet in length. They are called "chopstick beans" in Vietnamese. These long beans are the immature pods of dry black-eyed peas. Select thin, dark firm pods; the smaller the pods, the younger and more tender they are. They are available from Chinese green-grocers or some Caribbean markets in the autumn. This vegetable is mostly enjoyed for its crunchy texture. Wash and cut into 2-inch lengths. Substitute string beans or tiny French green beans (haricots verts).

TARO ROOT (*khoai mon*) This oval-shaped tuber is distinguished by its brown, hairy skin with encircling rings. The flesh may vary from white to cream-colored, and is often speckled with purple. It tastes like bland potato with a very smooth, creamy texture. Vietnamese cooks use this starchy root the same way you would a potato or sweet potato. Small peeled chunks are usually steamed and added to a stew or sweet pudding.

WATER SPINACH (*rau muong*) This aquatic plant may be considered Vietnam's national vegetable. It is not a relative of the Western spinach but is used in much the same way. It thrives in swamps but grows equally well on dry land. It has hollow stems and light green arrowhead-shaped leaves. It is prized by Vietnamese cooks for its outstanding contrast in texture between crunchy stems and limp leaves, and its spinach-like mild taste. It is sold by the bunch at Chinese and Vietnamese green-grocers. Soak in water and wash thoroughly before using. To use, cut into 2-inch lengths and discard the stalk's bottom inch or so. It is good for stir-fries and soups. The stalks may be finely shredded, soaked in cold water to curl, and then added raw to salads. Substitute regular spinach.

HERBS, GRASS, AND SEASONINGS

CARAMBOLA (*khe*) Also called "star fruit,"carambola is a deeply ribbed yellow-green tropical fruit that is ovoid in shape. Sliced, it yields star-shaped pieces that are beautiful for garnishing. Traditionally, the unripe, sour fruit is eaten raw in salads. It can replace tamarind for seasoning soups.

CHILES (*ot*) Vietnamese cooks use two basic varieties of chiles. First, there is the large, elongated red or green chile, resembling the Italian pickling pepper. Mildly hot, it is used sliced or whole for garnishing. It is available in Asian markets, Caribbean green-grocers and some supermarkets. The second type is a tiny, fiery hot pepper called a "bird" pepper, used for seasoning. These green and red chiles are usually found mixed together in small plastic bags and sold in Vietnamese and Thai markets. Refrigerate or freeze, wrapped in a plastic bag. Substitute fresh cayenne peppers or Mexican serrano chile peppers.

CHINESE CHIVES (*he*) These long, flat green chives resemble large blades of grass. The flavor is reminiscent of garlic as well as onion. They are a common ingredient of the Vietnamese vegetable platter (page 21) and Fresh Summer Rolls (page 18). They may be used as you would Western chives. Chinese chives are sold by the bunch. Refrigerate, wrapped in a plastic bag, for up to 3 days.

CORIANDER, fresh (*rau ngo/mui*) Also known as cilantro or Chinese parsley, this leafy green herb resembling flat-leafed parsley is highly scented, with a tart and refreshing taste. It is a prerequisite in Vietnamese cookery; without it, Vietnamese food would not be authentic. Refrigerate, wrapped in a moist paper towel and placed in a plastic bag. Like most fresh herbs, coriander should be added to a hot dish at the very end, since heat dissipates the flavor.

GINGER (*gung*) Always use fresh ginger when you can; powdered ginger is a very poor substitute. Fresh ginger is available in Asian markets, Caribbean green-grocers and in most supermarkets. Select young rhizomes that are sweeter and more tender than older ginger, which is identified by large hair or fibers protruding from the root. Ginger can be frozen or refrigerated for months. Contrary to popular belief, it is not necessary to peel ginger; the skin contains the vitamins. Ginger is used for both its aromatic and chemical effects. It is added to fish, seafood, and organ meats, not only to mask or remove objectionable odors, but to lend a subtle piquancy to the dish as well.

LEMONGRASS (*xa*) Also called citronella root, lemongrass is an aromatic tropical grass that characterizes Vietnamese and Thai cuisine. Only the bulb-like base of the stalk is used to impart a compelling balm-like flavor to food. It isn't always available fresh, so when you find some, buy a few bunches. Cut off the bulb portion at the point where the leaves begin to branch out, discarding the loose leaves. Freeze, wrapped in a plastic bag. When needed, peel off a layer of the tough outer leaves to reveal a white underlayer; crush lightly before slicing or chopping to release more flavor.

SUGAR CANE (*mia*) Sugar cane is a tall tropical grass, having a fat, jointed stalk resembling bamboo. The juicy yellow flesh is spongy and stringy. In Vietnam, the pressed juice from the canes is served as a soft drink in the summer. Mulled with ginger, it becomes a hot beverage for the winter. It is sold fresh at Caribbean green-grocers and Asian markets, but it is more readily available canned. Fresh sugar cane requires peeling.

THAI BASIL (*rau que*) This tropical anise-flavored basil, with purple stems and flowers, is available only at Vietnamese and Thai markets. Also known as Asian basil, this herb is exceptionally flavorful. It is a prerequisite for flavoring *Pho*, a famous beef and noodle soup. Substitute purple basil or regular sweet basil.

TROPICAL MINT (*bac-ha*) Of the numerous Asian mint species, the round-leafed mint, a tropical variety of spearmint, is the one most commonly used by Vietnamese cooks. This fragrant herb is an integral part of Vietnamese salads, especially in the traditional vegetable platter (page 21). Refrigerate, wrapped in a moist paper towel, in a plastic bag.

SUNDRIES AND FLAVORINGS

Most of the following ingredients have a long shelf life if kept very dry in tightly covered containers, preferably out of the sun.

AGAR-AGAR (*thach-hoa*) Agar-agar is a gelatin derived from refined seaweed. It is available in 2 forms: packages of two 10-inch-long rectangular sticks (*kanten* in Japanese), or 2 ounce to 4-ounce packages of 14-inch translucent strands that resemble crinkled strips of cellophane. It is widely used in southwest-Asian cooking for molded jellied sweets, as it sets without refrigeration in temperatures up to 100 F. To use agar-agar, soak it in warm water for 30 minutes. Squeeze the pieces dry. Add to cold water in a sauce pan (as a general rule, $1/2$ stick of *kanten* or $2/3$ ounce of agar-agar will thicken 4 cups liquid) and simmer until the agar-agar dissolves completely, Add sugar or other ingredients and heat again just to a boil. Pour into a mold or dish and refrigerate until set.

ANCHOVY SAUCE (*mam nem*) A blend of fermented anchovies and salt, this sauce comes bottled and has to be diluted and seasoned to make the traditional *Mam Nem* sauce (page 31). It is available in Vietnamese and Thai groceries; the best brand is Saigon's Mam Nem. Store it in the refrigerator after opening. Substitute canned anchovy or anchovy paste mixed with a little water.

BANANA LEAVES (*la chuoi*) In Vietnam, banana leaves are used to wrap foods for steaming or carrying. The food is served in the leaf, but the leaf itself is not eaten. It is sold fresh or frozen in 1-pound packages

in Latin-American and Asian markets. To use, thaw (if the leaves are frozen), then dip the leaves briefly in boiling water to make them pliable. Usually, an overwrapping of foil is necessary to prevent water from seeping into the food. Store unprepared leaves in the freezer. Substitute Ti leaves (available fresh at florists) or foil.

CHILE PASTE (*tuong ot tuoi*) A fiery hot mixture of mashed fresh red chiles, garlic, salt and soybean oil. Do not confuse this product with the Chinese hot bean paste. Look for Huy Fong brand. It is used as a table condiment and seasoning in soups and salads. Substitute Sambal oeleck or Tabasco.

COCONUT MILK (*Nuac dua*) Coconut milk is the chief ingredient used in preparing Vietnamese curries and sweets. It is the liquid wrung from grated and soaked coconut meat. The clear and flavorsome juice inside the hard shell is called coconut water; it is mainly used as a soft drink or as a tenderizing agent in stews and fondues. It is much easier to buy canned or frozen coconut milk, available in Asian or Caribbean markets, than to make your own. Do not confuse coconut milk with coconut cream, a heavy, sweetened coconut product often used in Latin-American cooking. Only unsweetened coconut milk is used in this book.

CURRY PASTE (*tuong ca-ri*) This chile oil-based curry paste is more pungent and spicier than curry powder. It is usually combined with curry powder to give a dish an assertive flavor. The best brands are Daw Sen and Golden Bell, sold at Indian and Chinese groceries.

DRIED SHRIMP (*tom kho*) These are shelled, dried, and salted shrimp with a pungent flavor, used in small quantities to season certain dishes, especially soups and stir-fries (they are not a substitute for fresh shrimp). The larger in size and the darker pink in color, the better the quality and the higher the price will be. Soak in warm water for 30 minutes or longer before cooking. Reserve the intensely flavorful soaking liquid; it will give a delightful lift to soups and sauces.

FISH SAUCE (*nuac mam*) Nuoc mam is like Thai *nam pla* only stronger. This thin, brownish sauce is obtained by fermenting salted fresh anchovies. It is a prerequisite in Vietnamese cuisine. Squid and Ruang Tong brands are widely available in Oriental markets and some supermarkets.

FIVE SPICE POWDER (*huong-liu*) This fragrant, reddish brown powder is a blend of ground star anise, fennel or anise seed, clove, cinnamon and Sichuan peppercorns. It is used to flavor barbecued meats and stews. If possible, buy it in small amounts as it is very strong and a little goes a long way. It keeps indefinitely in a covered jar.

FLOWER WATERS/ESSENCES (*nuoc hoa*) In Vietnam, flower water and essences are often used to flavor sweet drinks and desserts. Most popular are jasmine, grapefruit and orange-blossom water. They are produced by distilling the fresh petals of these flowers. You may substitute flower essences, but they are more concentrated; use only a few drops. Flower waters and essences are sold in Asian or Indian markets, liquor stores, and pharmacies.

GALANGAL (*rieng*) Also known as *laos*, its Indonesian name, galangal resembles ginger but has zebra-like markings and pink shoots. If it is unavailable, substitute fresh ginger juice or ground galangal. Dried galangal is used only in soups and stews; soak before using. It is sold in Vietnamese and Thai stores.

GLUTINOUS RICE (*gao nep*) Also called "sweet rice" or "sticky rice." There are 2 types of glutinous rice: the Chinese and Japanese short-grained type and the longer-grained Thai variety, which is favored by the Vietnamese. This rice has a soft, sticky texture with a slightly sweet flavor when cooked. Stuffed with mung bean paste and fresh bacon, it becomes rice cake (*Banh Trung*), a New Year's favorite. It is available at Vietnamese and Thai markets. Substitute Japanese moki rice. For cooking instructions see page 57.

GRASS JELLY (*thach-den*) Also known as *xinh-xao* or *liangfen* agar jelly in Chinese. Prepared from seaweed and cornstarch, this black jelly tastes and smells faintly of iodine. It is sold in cans in Asian markets. Drain and dice or shred the jelly before adding it to soybean milk or sweet drinks made of simple syrup, coconut milk, or crushed ice and a few drops of jasmine water.

GYPSUM (*thach-cao*) Chemically known as calcined calcium sulfate, gypsum is also called "plaster of Paris" or "plaster stone." This chemical agent has been used by the Chinese as a coagulant for bean curd for over a thousand years. It is sold at Chinese pharmacies.

HOISIN SAUCE A sweet, piquant brown paste made from soybeans, red beans, sugar, garlic, vinegar, chile, sesame oil, and flour. Vietnamese cooks often mix it with broth, fresh chile pepper, and ground peanuts to make a dip. It is also used as a barbecue sauce for meat and poultry. Available in cans and jars, different brands have slightly different flavors; Koon Chun is a slightly spicier brand. Refrigerate after opening.

LILY BUDS (*hoa hien/kim cham*) Also called "golden needles," these are the buds of a special type of lily (*Hemerocallis fulva*). The pale gold, 2-inch to 3-inch-long dried buds are often used in combination with tree ear mushrooms and cellophane noodles to add texture to stir-fries, soups, and stuffings. Soak them in warm water for 30 minutes, then remove the hard stems before cooking.

LOTUS SEEDS (*hat sen*) These seeds of the lotus plant resemble large round peanuts. In Vietnam where very fresh, young lotus seeds are available, they are eaten raw, used in stews, soups (especially in vegetarian cooking), and sweet confections. They also may be mashed into a paste and used as a filling for moon cakes. Canned and dried lotus seeds are sold in Chinese markets. Canned lotus seeds need no preparation, while the dried ones must be soaked in water overnight and then boiled until tender.

MUNG BEANS, Yellow (*dau xanh*) Green mung beans are normally used to grow bean sprouts. Husked, green mung beans become yellow mung beans. Yellow mung beans are often used in preparing starchy dishes and sweets. They are sold in Asian and Indian markets as "peeled split mung beans." Look for Cock or Summit brands.

MUSHROOMS, CHINESE BLACK (*nam huong*) These dried mushrooms are sold in 8-ounce packages in Oriental markets. They are expensive but highly esteemed for their distinct, robust flavor and succulent texture. There are different varieties but the best are *fah goo* (Chinese). They are 1 to 2 inches in diameter, have thick caps, and are light brown in color with prominent white cracks on their surface. Generally, they are very fragrant. Dried mushrooms require soaking. Strain and save the soaking liquid to add flavor to stocks and sauces. Though fresh or dried Japanese shiitake mushrooms are not as flavorful, they may replace Chinese mushrooms.

MUSHROOMS, STRAW (*nam rom*) Attractive umbrella shaped caps with a yellowish-brown color distinguish these mild flavored mushrooms. They are also known as "paddy straw" mushrooms because they grow on straw and rice husks. Considered a delicacy, they are added to soups and stir-fries. Straw mushrooms are available "peeled" in cans, in most Asian markets and in some supermarkets. Substitute canned button mushrooms.

MUSHROOMS, TREE EARS (*nam meo/moc nhi*) Also called cloud ears or wood ears. The "ear" designation of these black, chip-like fungi refers to their convoluted shape, resembling of a human ear. The best tree ear mushrooms are the very tiny, wrinkled and bark-like specimens often are mislabeled as "dried vegetables." When soaked in water, they expand to four or five times their original size and become jellylike and translucent yet remain crisp. They are mainly used to add texture to stir-fries, stuffings, and vegetarian dishes.

OYSTER SAUCE (*dao han*) Oyster sauce is a thick richly flavored, slightly sweet-salty brown sauce made from oyster extract, soy sauce, sugar, and vinegar. The flavor of different brands varies considerably; one of the best is Panda brand. It is sold in Asian stores and most supermarkets. It is mainly used to season stir-fries.

PEANUTS (*dau phong*) Peanuts are an important ingredient in Vietnamese cooking. Raw peanuts are preferred because they are usually roasted and ground just before serving to release their intense nutty flavor. Peeled raw peanuts are sold in Asian markets. Peanuts are used for texture and flavor in dipping sauces and as a garnish for cooked food. Substitute dry-roasted, unsalted peanuts.

PICKLED SHALLOTS (*cu kieu chua*) These are the very young, tender bulbs of scallions (spring onions), packed in vinegar, sugar and salt. They are used as a condiment to accompany grilled foods and noodle dishes or are used to season sweet-and-sour dishes. Pickled shallots, sometimes called "pickled leeks," are sold in jars or cans in Asian stores. The best quality comes in a jar; look for Mee Chun Champion brand. Drain before using.

PORK SKIN, dried, shredded (*bi heo kho*) These are sold only in Vietnamese markets. Look for Viet My or Golden Dragon brands.

PRESERVED VEGETABLES (*tan xai*) Called *chong choy* in Chinese, this condiment is a mix of cured bits of Chinese cabbage and seasonings. It is sold in small crocks at Chinese markets. Because of its extreme pungency, only small amounts are used to add flavor to soups and noodle dishes. As it is quite sandy, be sure to rinse thoroughly before using.

RICE PAPERS, dried (*banh trang*) These round, translucent little brittle sheets are made of rice flour, water, and salt and are sold in Asian markets. Their cross-hatch pattern comes from being dried on bamboo trays. They are essential in preparing the national dish *Cha Gio*. They come in various sizes of round and triangular shapes. The round papers are used for spring rolls and placed at the table to wrap grilled foods. Store, sealed in a plastic bag, in a cupboard. Soften one sheet at a time in warm water until pliant and ready to use. There is no substitute. Chinese egg-roll wrappers will not do as they are too thick.

RICE POWDER, roasted (*thinh*) A perquisite in Vietnamese cooking, this traditional flavoring may be bought in Vietnamese groceries or may be easily prepared at home; see instructions on page 28.

RICE VINEGAR (*giam gao*) I use rice vinegar instead of white vinegar in numerous recipes for its mild, sweeter taste. Sold in Asian markets and supermarkets, the Japanese varieties Marukan and Chikyu-uma are excellent.

ROCK SUGAR (*duong phen*) Also called "rock candy" or "yellow rock sugar," the name aptly describes this sweetener that looks like a crystallized rock. It is made from white sugar, brown sugar and honey and much sweeter than regular sugar. It is sold in 1-pound bags in Chinese groceries. Store in the refrigerator. Cover the lumps with a

cloth, then crush into a powder using a mallet or hammer. It is used to season Vietnamese sausages and meatballs. Substitute white sugar.

SESAME OIL (*dau me*) This Oriental type of sesame oil is a rich-flavored, amber-colored oil obtained from pressed roasted sesame seeds. A dash or two is added to marinades or at the last moment of cooking to flavor certain dishes. Do not confuse this type of oil with the cold-pressed, unroasted sesame oil sold in health food stores, which is insipid in flavor. Look for Kadoya brand. Store in a cool, dark place to prevent rancidity.

SESAME SEEDS (*me*) Sesame seeds are sold hulled or unhulled in Asian markets, health food stores, and supermarkets. Hulled white sesame seeds are preferred. A day-to-day ingredient in Vietnam, toasted and crushed sesame seeds are used to flavor dipping sauces and marinades or to coat sweets and other foods. After roasting, they lose flavor rapidly, so be sure to toast them as close to serving time as possible.

SHRIMP CHIPS (*banh phong tom*) Labeled as "prawn crackers" (or *kroepoek* in Indonesian), these dried, reddish-pink chips are made from ground shrimp, tapioca starch, and egg whites. In Vietnam, they are a popular snack and salad accompaniment. They are sold in small and large sizes, but the small chips are usually tastier. Look for Pigeon brand, packed in an 8-ounce box. Shrimp chips must be deep-fried before serving. As their Vietnamese name indicates (literally, puffed shrimp chips), they swell to triple their size as soon as they hit the hot oil. For instructions on cooking shrimp chips, see page 16. Store tightly sealed in a plastic bag.

SHRIMP SAUCE (*mam tom/mam ruoc*) This very pungent product is made from pounded, salted fermented shrimp. It is grayish pink and sold in bottles and jars in Vietnamese and Chinese grocery stores; Lee Kum Kee brand is excellent, but try to obtain, Mam Ruoc Ba Giao Thao, the best Vietnamese product on the market. In Vietnam, shrimp paste is commonly used to flavor soups, salads, dipping sauces, fried rice, and dishes containing pork or beef. Do not confuse with Thai dried shrimp paste. Substitute anchovy paste.

SOYBEANS, dried (*dau nanh*) Soybeans are the edible dried seeds of the glycine soja plant. Used in the production of bean curd (tofu), they are the main ingredient in preparing soybean milk and jellied bean curd. They are sold in Oriental groceries.

SOYBEAN SAUCE (*tuong*) A traditional light brown sauce prepared from a soybean product in which the ground beans are mixed with water, roasted rice powder, and salt. It is sold only in Vietnamese groceries. Do not confuse soybean sauce with the saltier, thicker Chinese ground bean paste. Vietnamese vegetarians commonly use this sauce. Substitute yellow bean sauce diluted with a little water.

SOY SAUCE (*si dau*) Where soy sauce is required in this cookbook, Japanese Kikkoman or "light" soy sauce should be used. It is lighter in color and different in taste and saltiness from regular Chinese soy sauce, which is dark and stains food black.

STAR ANISE (*hoi huong*) Star anise is the dried pod of an exotic tree of the Magnoliaceaes family, native to China. Mainly grown in the Lang-Son region (North Vietnam), this bark-like spice has cloves that resemble an eight-pointed star. Unrelated to anise seed, it yields a strong licorice flavor and is used to enhance soups and stews. When chewed, it sweetens the breath and aids in digestion. Star anise is sold in Asian markets and spice shops. Substitute anise seed.

TAMARIND (*me chua*) A sour tasting soup with shelled pods that contain seeds, it is usually added in liquid forms to flavor soups, and this is obtained by soaking and straining the pulp of the tamarind pod. The pulp is sold soft-dried in 8-ounce blocks. Erawan brand is excellent. Stored in an airtight container at room temperature, it will keep indefinitely. Substitute lemon juice or vinegar with a touch of sugar.

TURMERIC (*bot nghe*) Turmeric is the ground powder of a rhizome of the ginger family. Deep yellow in color, this spice is used primarily as a dye. It is sold in the spice section of all supermarkets.

YEAST BALL (*men*) Men is also known as "wine ball," an Oriental dry yeast used in making rice wine. It is sold in Vietnamese and Chinese food stores or pharmacies. Relatively small, this round grayish ball is usually sold in pairs, wrapped in a tiny plastic bag; you may need to ask for it.

MEATS AND SAUSAGES

CHINESE SAUSAGE (*lap xuong*) Chinese sausages may be made from pork, duck liver, or beef, but pork is most popular. These dried, red, sweet sausages (*lap chong* in Cantonese) are sold hung by the strings in Chinese meat markets, or in 1-pound packages in Asian groceries. Blanch before cooking (to make the sausage less fatty). An easy, delicious way to cook this sausage is to place it directly on top of rice as it cooks in a pot.

VIETNAMESE PORK SAUSAGE, boiled (*gio*) This savory sausage is a very important ingredient in Vietnamese cuisine. It is sold wrapped in banana leaves and aluminum foil, and available only in Vietnamese groceries. Keep some on hand in your freezer.

NOODLES

CELLOPHANE NOODLES (*mien/bun tau*) Also called bean threads or mung bean vermicelli. Cellophane noodles are not really noodles but rather a vegetable product made from mung bean starch. They are used primarily for their texture in soups and stuffings. Soak in warm water for 30 minutes, then cut into shorter lengths before cooking. If they are to be deep-fried, cook them straight from the package (they will puff dramatically in hot oil), then use as a nest for stir-fries. They are sold in 1-pound or 2-ounce packages in Asian stores and some supermarkets.

EGG NOODLES (*mi*) In areas with a substantial Asian population, egg noodles are available dried or fresh in Chinese markets. Two popular varieties are the long extra-thin Cantonese style egg noodle strands called *don mein*, often swirled into a nest, used for deep frying, and the broader egg noodles called *fu don mein*, about 1/4-inch wide and flat, used in soups. Fresh egg noodles are preferrable. Do not confuse them with chow mein noodles. Store in plastic bags in the freezer for months or in the refrigerator for 3 to 4 days.

RICE STICKS (*banh pho*) Also called "dried rice sticks." Rice sticks are flat thin noodles made from rice flour and water; they are available dried in 1-pound packages in most Asian markets. There are 3 sizes to choose from: wide, medium and narrow strands. The wide variety is used primarily in stir-fries, although some people like to use it in soups. The medium size s most popular; it is used in the traditional soup, *pho*, in cold or warm noodle soups and stir-fries. The narrow size is more suitable for noodle soups.

RICE VERMICELLI, THIN (*bun*) Called *mai fun* in Chinese, these thin, brittle, white rice noodles are dried in 8-inch looped skeins. They are packaged in layers and sold in Asian markets. Look for Double Swallow or Mount Elephant brands. *Bun* are used in soups or noodle salads and are served cold at the table as an accompaniment to grilled or curried dishes. The best substitute is Japanese alimentary paste noodles or *somen*. For cooking information see page 60.

RICE VERMICELLI, EXTRA-THIN (*banh hoi*) As *bun* above, *banh hoi* is a rice noodle variety as fine as hair, possibly the thinnest of all noodles. They are packed, dried, in 1-pound packages containing 8 individual portions swirled into a square cake. Look for Summit brand. *Banh hoi* are so thin, they need almost no cooking. They are used primarily as an accompaniment to grilled foods.

SOMEN (Japanese alimentary paste noodles) Delicate thin white noodles made from wheat flour, *somen* resembles the traditional *bun* (rice vermicelli) of Vietnam in texture and flavor. Even after cooking, *somen* stays moist at room temperature or refrigerated. It comes in 1-pound boxes with 5 individual bundles tied by a black ribbon. For cooking information see page 60.

FLOURS AND THICKENERS

POTATO STARCH (*bot khoai*) Potato starch is added to meatballs and pates as a binder, yielding a slightly crunchy texture. Potato starch is available in the foods department of supermarkets and in Asian markets.

RICE FLOUR (*bot gao/bot te*) This is a type of flour made from long grain rice. Do not confuse it with glutinous rice flour, which is made from sweet rice; the two are not interchangeable. Rice flour is the basis for many rice noodle dishes and sweets. Erawan and Tienley are two excellent brands. Rice flour is sold in 1-pound bags in Asian markets.

RICE FLOUR, GLUTINOUS OR SWEET (*bot nep*) Glutinous or sweet rice flour is made from glutinous rice. It is used to make sweet confections. Look for Erawan or Peacock brands in Asian markets and for Mochiko in Japanese stores.

TAPIOCA STARCH/FLOUR (*bot nang*) This is the starch of the cassava root and a very important ingredient in preparing fresh noodle wrappers, it gives them a translucent sheen and chewiness.

TAPIOCA PEARLS (*bot bing-bang*) These are granules made from the starch of the cassava root. Pearl tapioca is used mainly as a thickener and texture ingredient in certain soups and sweet puddings. It is available in Asian groceries and many supermarkets, packed in 8-ounce bags.

CONVERSIONS

Liquid Measures

Fluid Ounces	U.S. Measures	Imperial Measures	Milliliters
	1 Tsp	1 Tb	5
1/4	2 Tsp	Dessert Spoon	7
1/2	1 Tbs	1 Tbs	15
1	2 Tbs	2 Tbs	28
2	1/4 Cup	4 Tbs	56
4	1/2 Cup or 1/4 Pint		110
5		1/4 Pint or 1 Gill	140
6	3/4 Cup		170
8	1 Cup or 1/2 Pint		225
9			250, 1/4 Liter
10	1 1/4 Cups	1/2 Pint	280
12	1 1/2 Cups or 3/4 pint		240
15		3/4 Pint	420
16	2 Cups or 1 Pint		450
18	2 1/4 Cups		500, 1/2 Liter
20	2 1/2 Cups	1 pint	560
24	3 Cups or 1 1/2 Pints		675
25		1 1/4 Pints	700
27	3 1/2 Cups		750
30	3 3/4 Cups	1 1/2 Pints	840
32	4 Cups or 2 Pints or 1 Quart		900
35		1 3/4 Pints	980
36	4 1/2 Cups		1000, 1 Liter

Solid Measures

U.S. & Imperial Measures		Metric Measures	
Ounces	Pounds	Grams	Kilos
1		28	
2		56	
3 1/2		100	
4	1/4	112	
5		140	
6		168	
8	1/2	225	
9		250	1/4
12	3/4	340	
16	1	450	
18		500	1/2
20	1 1/4	560	
24	1 1/2	675	
27		750	3/4
28	1 3/4	780	
32	2	900	
36	2 1/4	1000	1
40	2 1/2	1100	
48	3	1350	
54		1500	1 1/2

Oven Temperature Equivalents

Fahrenheit	Gas Mark	Celcius	Heat of Oven
225	1/4	107	Very Cool
250	1/2	121	Very Cool
275	1	135	Cool
300	2	148	Cool
325	3	163	Moderate
350	4	177	Moderate
375	5	190	Fairly Hot
400	6	204	Fairly Hot
425	7	218	Hot
450	8	232	Very Hot
475	9	246	Very Hot

INDEX